IMAGES
of America

HISTORIC DOWNTOWN
CINCINNATI

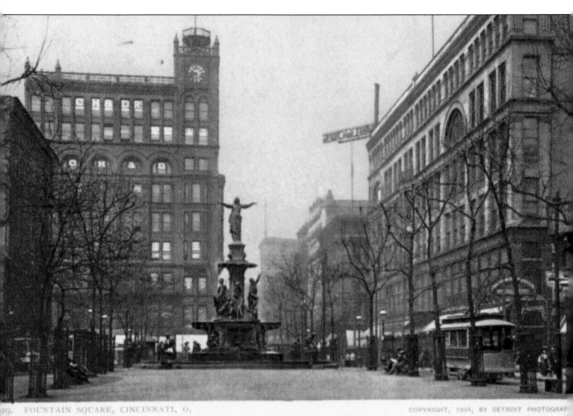

FOUNTAIN SQUARE, CINCINNATI, O. COPYRIGHT, 1904, BY DETROIT PHOTOGRAF

Described by one Cincinnati newspaperman as an "old bronze candlestick," the Tyler Davidson Fountain remains the cultural hub of downtown Cincinnati. Best known for its appearance in the opening of *WKRP in Cincinnati*, the fountain is most certainly a gift "To the People of Cincinnati." The figures depict the benefit of water, quite fitting for a river city. (From the Collection of the Public Library of Cincinnati and Hamilton County.)

ON THE COVER: From the days of the steamboats to modern expressways, downtown Cincinnati has always been a busy place of commerce and entertainment, as is clearly seen here in this turn-of-the-century photograph of Fifth Street, the heart of downtown Cincinnati. (Courtesy of the Cincinnati Museum Center, Cincinnati Historical Society Library.)

IMAGES
of America

HISTORIC DOWNTOWN
CINCINNATI

Steven J. Rolfes and Kent Jones

To Tony,

Best Wishes

ARCADIA
PUBLISHING

Copyright © 2011 by Steven J. Rolfes and Kent Jones
ISBN 978-0-7385-8291-7

Published by Arcadia Publishing
Charleston, South Carolina

Printed in the United States of America

Library of Congress Control Number: 2011927552

For all general information, please contact Arcadia Publishing:
Telephone 843-853-2070
Fax 843-853-0044
E-mail sales@arcadiapublishing.com
For customer service and orders:
Toll-Free 1-888-313-2665

Visit us on the Internet at www.arcadiapublishing.com

For Brenda, Darren, Brandan, Adam,
Mike, Terri, Selena, Jordan, and James

Contents

ACKNOWLEDGMENTS

This book would not have been possible without the help of a number of very supportive people. We would like to thank everyone associated with the Public Library of Cincinnati and Hamilton County Greater Cincinnati Memory Project and the Southwest Ohio and Neighboring Libraries. Without the assistance and cooperation of Kimber Fender, Diane Mallstrom, and Glen Horton, this book would not exist. We would also like to thank Elaine Kuhn at the Kenton County Public Library, and Linda Bailey of the Cincinnati Historical Society Library. Thanks to Jordan Rolfes for wandering around downtown taking photographs in 14-degree weather—and for his help with computers and images, and Terri for the clerical assistance. Many thanks to Doug Weise for his marvelous photographs—and the man in the Marriot in Covington, Kentucky, who let Doug go up in the building for the perfect spot to photograph the little "temple" on top of the Union Central Tower (PNC Building) featured on page 85. And, of course, many thanks to Melissa Basilone, our editor at Arcadia Publishing, for her expert guidance and encouragement, and always answering questions with a positive outlook. Thanks to John Pearson, also at Arcadia Publishing, for helping get this project off the ground. As always we thank our Lord for His many blessings.

INTRODUCTION

When Rosetta Armstead stepped off of the gangplank of the steamboat in 1855, she had no idea where her journey would end, or that two great men would help her along her way. One of her helpers would one day become the chief justice of the Supreme Court; the other would one day be president. These two powerful men would reach down and help a young woman in her time of distress.

Rosetta was only 16 years old and a slave. Owned by Henry M. Dennison, a Kentucky clergyman, she had been asked if she wanted to make the trip. Perhaps with a teenage girl's yearning for adventure and desire to see a big city, she gladly agreed.

Downtown Cincinnati had for many years been the destination of slaves. Hundreds had come before her, many covered under tarps in rowboats, hidden away amidst barrels of whiskey and bales of cotton on steamers. For these men and women, downtown Cincinnati was a bridge, a doorway to a new life of freedom. No, it was not the final destination—only Canada, far to the north, could guarantee that there would be no slave catchers dragging them back in chains to the South. But this incredible city . . . this was the *line*! Beyond that muddy river, in that beautiful wild city with the tall buildings, there were no slaves. Cincinnati was the door, and on the other side of that door was freedom.

Reverend Dennison was not present as Rosetta was taken north toward Columbus, but he had entrusted her care to a friend who acted as her guardian. The clergyman was no doubt shocked to find that the group had been detained by abolitionists, and now his property was on trial for her freedom.

The matter was soon in Probate Court in Columbus. Under a writ of habeas corpus, Rosetta was placed under the temporary court-appointed guardianship of Lewis Van Slyke. By now, her owner had stormed into the proceedings and demanded that his property be returned to him. Convinced that she liked her state in life, in the presence of the judge Dennison asked Rosetta to choose for herself if she wanted to be free or remain with his family. To his shock, Rosetta turned her back on him and chose freedom. Dennison stomped out of the court, shouting that he was through with this ungrateful girl forever.

But things would not be so easy. Somewhere between Columbus and Cincinnati, Dennison changed his mind. He filed suit in Cincinnati to have his property returned. Rosetta was arrested and returned to Cincinnati for trial.

Rosetta's fate was now in the hands of her two volunteer lawyers. One was a man who was not particularly a friend of the abolitionists; indeed, he was a rather conservative Whig. However, both he and his wife detested slavery, and he was a darn good lawyer. His name was Rutherford B. Hayes. Helping him was a fierce, fiery abolitionist: a New England man named Salmon P. Chase.

Hayes had defended runaway slaves over the years, including a very brave man named Louis. While the judge and the attorneys were busy arguing about his fate, Louis simply stood up and calmly walked out of the courtroom.

Cincinnati, sitting right on the border with the South and tied with commercial interests to Dixie, was not always a friendly place for slaves struggling to secure their freedom. Two years

earlier, Judge Jacob Flinn, a notorious pro-slavery magistrate, became so incensed that he physically attacked an abolitionist lawyer who happened to be walking along the street!

Thankfully, the violent bigot Flinn would not preside over Rosetta's fate. Standing before the far more impartial Judge James Parker, Hayes presented a very complex case in a cool, intelligent, and compelling manner. While case law proscribed the returning of runaway slaves to their Southern owners, Rosetta was technically not a runaway. She had come to Cincinnati with her master's blessing. Her owner had even given her a choice in front of a judge between freedom or slavery. Now, despite the reneging of the promise on the behalf of the clergyman, Rosetta had made her wishes quite clear. The final sticking point was whether or not the federal government had the power to overstep a writ of habeas corpus. Was there a legal right to transport slaves through the free state of Ohio?

Poor Rosetta, sitting in that courtroom, was no doubt utterly bewildered by the proceedings. But she had no trouble understanding when Judge Parker issued his decision. Thanks to the hard and unpaid work of Hayes and Chase, Rosetta Armstead was now legally a free woman.

Cincinnati had indeed been the gateway to freedom and a new life for her.

Things did not go as well for another slave woman on January 28th of the next year. The cold was so overwhelming that it froze the entire river in front of downtown Cincinnati, creating a perilous and uncertain land bridge to the free state. On that frigid night, clutching her children close to her, Margaret Garner and her husband made their way across the treacherous ice. They moved quickly and carefully, using the lights and sounds of downtown Cincinnati that had so entranced Rosetta a year before as a beacon to guide them.

They reached downtown Cincinnati safely. They should have stayed there and blended in with the crowds. Instead, the Garner family left downtown, stopping for rest and supplies at the home of a relative. That was their mistake. Here, the slave catchers stormed in to drag the family back to Kentucky in chains. But Margaret, in an act of unimaginable bravery, grabbed a kitchen knife and thrust it into the heart of her two-year-old daughter Mary! She would rather see her child dead than a slave. She would have murdered her other children, but there was not enough time. Thus, in an act of desperation, Margaret Garner earned the grisly title "the American Medea."

Today, visitors to downtown Cincinnati's National Underground Railroad Freedom Center can see Thomas Satterwhite Noble's 1867 painting *The Modern Medea*, which depicts this ghastly event.

Seven years later, another man was approaching downtown Cincinnati, searching for freedom from bondage. However, he was no escaped slave, and he was not fleeing north. For him, freedom meant the South. He and a handful of men had just escaped from the Ohio Penitentiary, and for him downtown Cincinnati was also a gateway.

The closer he approached to Cincinnati, the more frightened he was that someone would recognize him. After all, it was only a few months earlier that his face was on every Cincinnati newspaper and his name on every Cincinnatian's lips. This was the man who was going to attack the great city of Cincinnati: he was to do to the Queen City what Burnside's uncontrollable troops had done to Fredericksburg.

He never attacked the heavily fortified downtown of Cincinnati, but did conduct raids nearby, trying desperately to draw Union troops away from Grant's siege of Vicksburg and Meade's battle with Lee at Gettysburg. The plan did not work—both battles were Union victories; both were so significant that, combined, they essentially ended any possibility of a Confederate victory.

This man sitting on a southbound train headed for downtown Cincinnati was disguised Confederate brigadier general John Hunt Morgan. The man sitting next to him, chatting away calmly about the events of the day, was an officer of the Union army!

In what must be one of the greatest ironies of American history, Morgan and a companion managed to cross the Ohio River to freedom near downtown Cincinnati—rowed across in secret by a black man!

The war that Morgan fought in ended two years later. But on an April night of that year, a young "tramp" telegraph operator would burst out into Court Street shouting to all passersby the

profound news that he had just passed along on the telegraph. His message was simple: "Lincoln shot!" The name of the operator was Thomas Edison.

Strangers stopped each other and told each other the news. Within the hour, word made its way further downtown to the ears of a famous actor who was in town performing at Pike's Opera House. As soon as he heard the tragic report, he fainted dead away. His name was Junius Booth. It was his son, John Wilkes Booth, who had murdered the president of the United States.

Sometimes, people would come to downtown Cincinnati not knowing what they would find. This was the case in 1881, when a young woman from Indiana stepped off a train in downtown Cincinnati, looking about with as much amazement as Rosetta had three decades before. She thought that she had come to the big city just to visit her sister, but she ended up falling in love. Sadly, the heart and the mind were not in conjunction, for she did not choose wisely. Her boyfriend, Joseph Payton, was a brute who was seemingly incapable of love. He turned her naïve feelings to his advantage, subtly transforming her from a country girl into a big city prostitute—with him keeping the money, of course. However, things did not go as expected. When he tried to discard her, as he had done with so many others, he found that she was still wildly in love with him and simply would not leave.

He decided to make the separation permanent by shooting her in the heart in her Fourth and Vine Street tenement. She stumbled back to her bedroom but never reached the bed. She collapsed, her blood permanently staining the wooden floor.

Her name was Nellie Stickeley, a name now forgotten. Few would imagine that her murder would help to form the mind of a man who would someday become president.

Payton, certainly no criminal mastermind, was quickly arrested and put on trial for murder. However, the one smart thing he did was to secure the services of Thomas C. Campbell as defense attorney. Campbell was both a political boss and an attorney of "questionable" methods.

In a trial that had everything short of clowns and acrobats, Campbell was able to convince the jury that his client was not guilty—he was simply too stupid to commit murder, in a legal sense. Somehow, by hook or crook, the jury bought it. They found Payton not guilty, by insanity. When the verdict was announced, the killer gloated, "I beat them!" His intemperate words were mostly directed at the young prosecuting attorney. That was a big mistake.

The prosecutor he was humiliating was an up-and-coming lawyer, William Howard Taft.

Taft, who wanted nothing more in life than to be a judge, never forgot the stinging rebuke he endured in that courtroom that day. Filled with anger at the miscarriage of justice and determination to change things, he began a lifelong campaign against political bosses in general, and T.C. Campbell in particular. Their paths would cross again.

On Christmas Eve of 1883, two young men on the western edge of downtown beat their employer to death to rob him. Once again, the lawyer for the first to be tried was none other than T.C. Campbell. This time, he went too far.

The killer, a German boy named William Berner, was only found guilty of manslaughter. People were already stressed after two years of devastating floods, the shock of a horrible case of two grave robbers murdering a family in Avondale, and now *this*. A meeting at Music Hall erupted into a massive riot. By the end of three days of street warfare, the courthouse where the trial had been conducted was burned to the ground. The riot was ended only when the militia fired a Gatling gun into the crowd.

Campbell was put on trial for possible disbarment. A junior member of the prosecuting team, William Howard Taft, made the opening remarks. But Campbell secured a not-guilty verdict. He did not gloat, but quickly fled the city—particularly after an arsonist burned his house down.

Taft's future was not to be what he thought. There was another Nellie just down at the end of Fourth Street, living across the street from his half-brother Charles. Charles had married David Sinton's daughter, Annie, and was now quite wealthy. Across the street was the home of a lawyer, John Herron. Herron's old law partner, Rutherford B. Hayes, had defended Rosetta 30 years before. When Hayes became president, he invited the Herrons to visit him in the White House. Young

middle daughter Helen, known to everyone as "Nellie," then and there decided that whomever she married would become president—and she would be the first lady.

She married William Howard Taft and personally saw to it that he would indeed become president.

While Taft was involved in politics and Campbell in exile, another man would quickly fill in the vacuum and take power over the city. He would sit in a corner booth in the Mecca Saloon on Walnut Street and greet a never-ending parade of people who wanted favors. With a simple nod of his head "yes" or "no," the man effectively ruled the entire city from that booth, and another booth in Weilart's Biergarten up in Over-the-Rhine. That man, a former councilman and saloon owner, was George Cox. He was the "Boss," possibly the most powerful city boss in the entire nation. Needless to say, he and Taft were bitter enemies.

Today there is a large banner hanging over Fountain Square, the physical and spiritual heart of downtown Cincinnati. This banner proclaims, "Life Happens Here." It does indeed, just as it has for more than 200 years. Downtown Cincinnati has always been a door—to the South, the North, the West, the door to opportunity in business, or the door to a chance for a better life in a new land. Once, one might have heard German spoken on a corner on Race Street. Now, one is just as likely to hear Spanish. People have come here for two centuries, looking for something. For some like Rosetta and Margaret (and General Morgan), it was freedom. For others, like those brothers-in-law Procter and Gamble, or those two Detroit shopkeepers who missed a train, Mabley and Carew, it was the opportunity to build a business.

The story of downtown Cincinnati is not just the story of tall and beautiful buildings, although there certainly are some very remarkable ones. It is not the story of statues and museums, although they are here, too. It is, instead, the story of the people who each day hustle about the canyons between the buildings, seeking their fortune, seeking love, seeking a good home. Every one of them has a story. After all, as the banner proclaims, "Life Happens Here."

One

THE EARLY DAYS

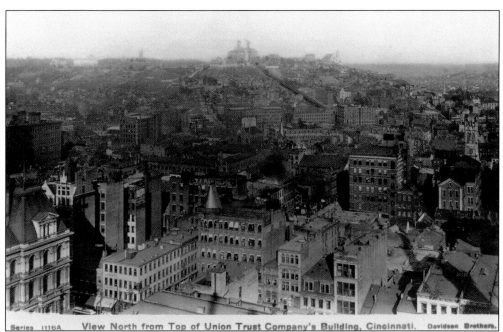

Downtown Cincinnati has always been separated on the north from Over-the-Rhine, first by a canal and later by Central Parkway. However, downtown spilled out in the east and the west. Today, expressways encircle the city. (From the Collection of the Public Library of Cincinnati and Hamilton County.)

Founded in 1788 by John Cleves Symmes and Col. Robert Patterson, the new settlement was originally named Losantiville. Two years later, territorial governor Arthur St. Clair changed the name to Cincinnati. (From the Collection of the Public Library of Cincinnati and Hamilton County.)

The first settlers in Cincinnati disembarked from the Kentucky settlement known as Limestone, now the city of Maysville. Their leader was Robert Patterson, the man who would later go on to found the settlement that would become the city of Lexington, Kentucky. (From the Collection of the Public Library of Cincinnati and Hamilton County.)

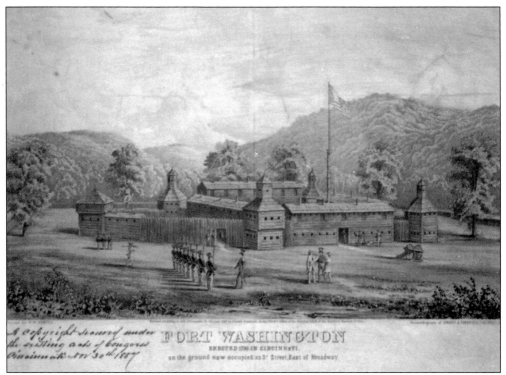

Only a year after the first settlers landed, Maj. John Doughty sent Capt. David Strong to choose the site of a fort along the Ohio. It was a military decision to locate Fort Washington here, across from the intersection of the Licking River. (Library of Congress, LC USZ62 1878.)

Certainly one of the most colorful parts of early Cincinnati, Front Street on the riverfront area was wild and seedy in the 1800s. The streets were crowded with dockworkers, crewmen from steamboats, prostitutes, drunkards, thieves, con men, gamblers—and a crow! The trained crow would attack strangers but would always fly away when a policeman approached, thus warning the unsavory residents. (From the Collection of the Public Library of Cincinnati and Hamilton County.)

13

Isaiah Rogers, the "Father of the 19th Century Grand Hotel," was the architect of the Astor House in New York and the Tremont House in Boston. In 1850, he designed the Burnet House, a true grand hotel that included shops for the convenience of visitors. (From the Collection of the Public Library of Cincinnati and Hamilton County.)

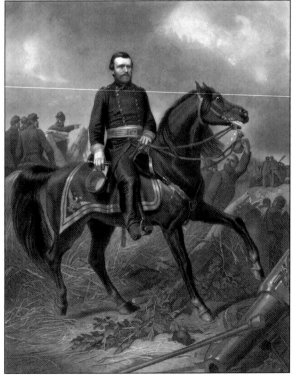

While it may be a bit of a stretch to say that the Civil War was won in downtown Cincinnati, there is no doubt that the seeds of the Union victory in the Civil War were sown in the Burnet House. Here, General Grant and his old friend General Sherman made their plans for the final two-pronged thrust against the Confederacy that ended the conflict. (Library of Congress, LC-DIG-pga-02645.)

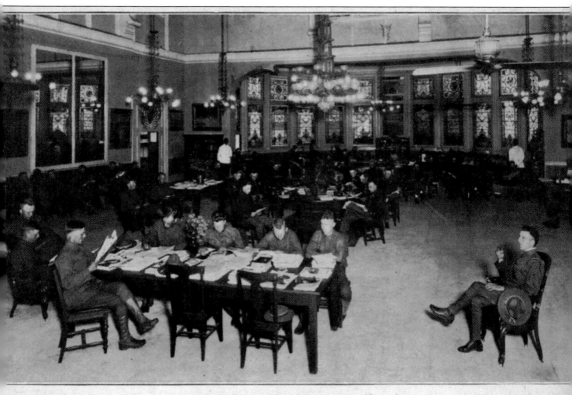

Comfort and Rest Room—East End
Soldiers' and Sailors' Club, Burnet House, Third and Vine, Cincinnati, Ohio

When Jacob Burnet first entered downtown Cincinnati in 1796, there were only log cabins to house a booming population of 500. The guest register of his Burnet House would contain the names of the Prince of Wales, Abraham Lincoln, Daniel Webster, Henry Clay, Sarah Bernhardt, and many others. Ironically, this hotel also served as a temporary prison for the lovely Confederate spy Lottie Moon. She and her sister Ginnie would become "engaged" to dozens of Union soldiers simultaneously, then ferret out military information from their love letters! The arresting officers did not want to place a woman in a military prison (particularly if she was a former lover of their commander), so they graciously put her up at the Burnet House. She was able to destroy evidence before going to her "prison." It was not long before her old boyfriend, Gen. Ambrose Burnside, released her. (From the Collection of the Public Library of Cincinnati and Hamilton County.)

HARPER'S WEEKLY.

A JOURNAL OF CIVILIZATION.

VOL. VI.—No. 300.] NEW YORK, SATURDAY, SEPTEMBER 27, 1862. [SINGLE COPIES SIX CENTS.
[$2 50 PER YEAR IN ADVANCE.

Entered according to Act of Congress, in the Year 1862, by Harper & Brothers, in the Clerk's Office of the District Court for the Southern District of New York.

THE CITY OF CINCINNATI, OHIO.—[See Page 615.]

On September 27, 1862, downtown Cincinnati became a cover model, in a sense. Cincinnati was a supply depot for the Army, a target for Confederate forces, a center of "copperhead" activity, and a meeting place for Confederate spies and sympathizers. Cincinnati gave a number of generals to the Union, including Lytle, Rosecrans, Weitzel, and the military family "the Fightin' McCooks." (Library of Congress, LC-USZ62-43386.)

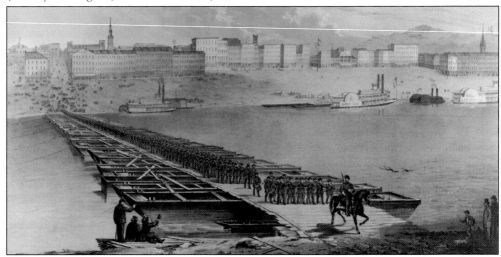

To prevent Kentucky from becoming part of the Confederacy, downtown Cincinnati once again became the gateway to the South. In 1862, a temporary pontoon bridge was erected, allowing the Union army to proceed south to what would culminate in the Battle of Perryville. (Library of Congress, LC-USZ62-137626.)

To Cincinnatians in 1863, this was the face of the devil: Confederate brigadier general John Hunt Morgan. Morgan launched his daring raid into Ohio to divert forces from the campaigns at Vicksburg and Gettysburg. It was feared that he would plant the Stars and Bars in downtown Cincinnati, but instead, he operated north of the city. (Library of Congress, LC-USZ62-16009.)

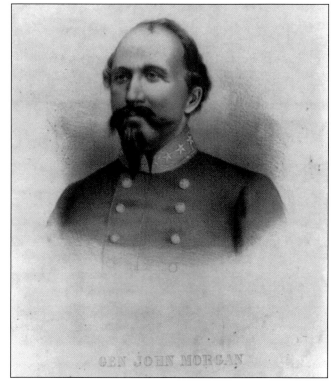

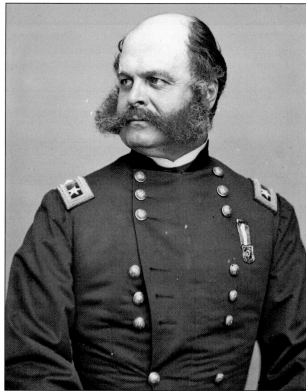

After his defeat at Fredericksburg, General Burnside became head of the Department of the Ohio. In 1863, from his Ninth Street headquarters, he issued Special Order 38, which made it a crime to show sympathy for the Confederacy and placed the accused under military rather than civilian justice. Among those arrested was Burnside's old girlfriend, Lottie Moon. He released her, unaware that Lottie really *was* a Confederate spy. (Library of Congress, LC-DIG-cwpb-05368.)

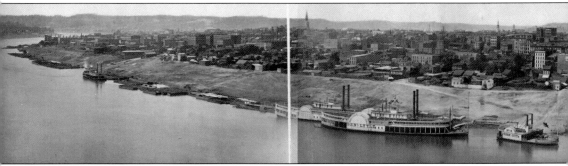

One advantage of Roebling's new suspension bridge was that it gave photographers the perfect spot to make a panorama view of downtown Cincinnati. Here is downtown Cincinnati in 1866, immediately following the Civil War. Cincinnati's most famous fallen general, William Lytle, was commemorated by having a steamboat named after him. A year earlier, Junius Booth was

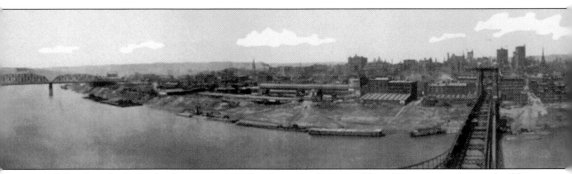

A few decades later, the downtown area has begun to be graced by taller, more ambitious buildings. While the city was growing architecturally, it was losing economically against cities such as Chicago and St. Louis. The ongoing expansion of the railroads made river traffic less important.

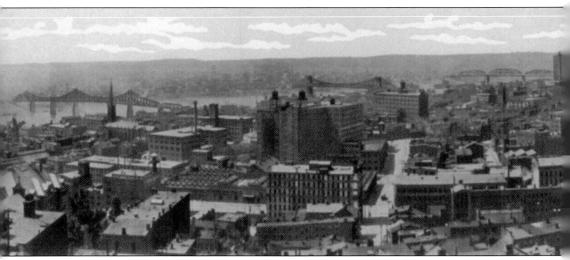

This panorama of the city was taken from Mount Adams overlooking the eastern fringe of downtown. This had been the location for artillery during the Civil War when it was feared that Confederate generals Kirby Smith or John Morgan would invade the city. The area in the

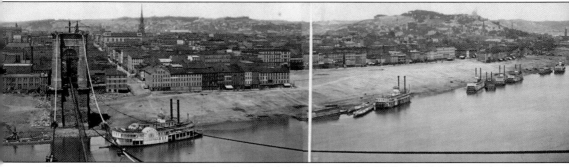

performing at Pike's Opera House when he heard that his son John Wilkes had shot Lincoln. He fainted straight away. Upon recovery, he quickly and quietly left the city. (Library of Congress, LC PAN US GEOG-Ohio No. 10.)

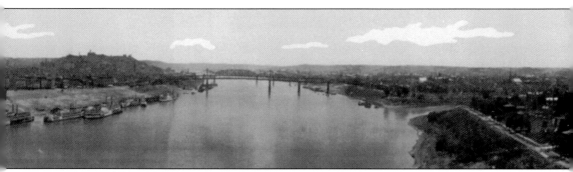

Cincinnati goods would sometimes sit idle on docks in Louisville while agents of downtown businesses scoured the South trying to drum up new markets. (Library of Congress, LC PAN US GEOG-Ohio No. 50.)

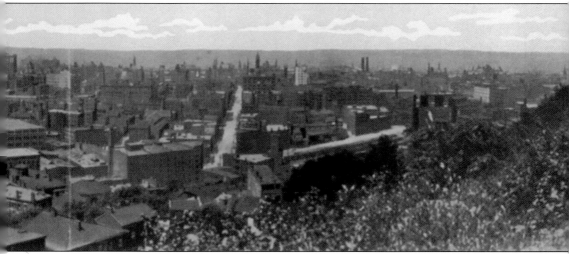

immediate bottom of the hill stretching to the riverfront was a tenement of Irish and African Americans, disparagingly called "Sausage and Rat Row" at the time. Today, these buildings are gone, replaced by expressways. (Library of Congress, LC PAN US GEOG-Ohio No. 49.)

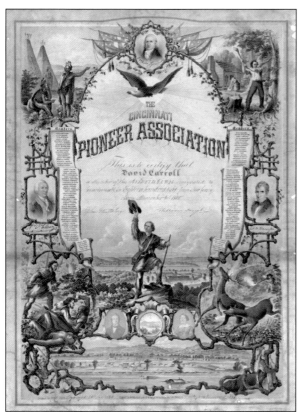

Cincinnatians have always been proud of their pioneer roots. Here is a certificate stating that David Carroll is a member of the Society of Cincinnati Pioneers. The downtown area of Cincinnati once was the furthest expansion into the untamed wilderness of the West. (Library of Congress, LC-DIG-pga-01138.)

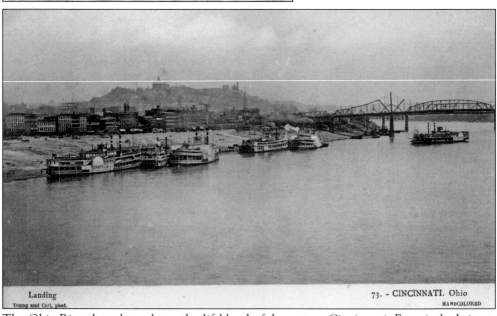

The Ohio River has always been the lifeblood of downtown Cincinnati. Even in bad times, Cincinnati was often a boomtown, due to its location on the river. Hundreds of steamboats would often be docked, creating a forest of smokestacks. These smokestacks meant one thing: business. (From the Collection of the Public Library of Cincinnati and Hamilton County.)

Two

HEY! WE'RE TALKIN' BUSINESS, HERE!

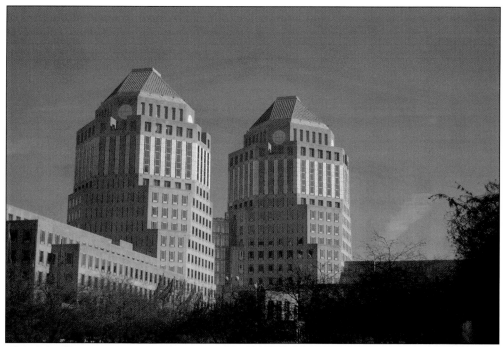

These are the "twin towers" of downtown Cincinnati: world headquarters of Procter & Gamble. William Procter and James Gamble married the daughters of Alexander Norris, who suggested that the two should merge their businesses. The partnership began on Halloween 1837. After accidentally discovering the "soap that floats," the company became a giant. (Photograph by Jordan Rolfes.)

Heart of Wholesale District, S. W. Corner Pearl & Vine Sts., Cincinnati, O.

Pearl Street was once a financial and cultural center, and later was a street of warehouses. It housed St. Philomena's Catholic Church, a museum, and the homes of Dr. Daniel Drake and the naturalist John James Audubon. Sadly, the entire street is now gone, having been converted into an expressway. (From the Collection of the Public Library of Cincinnati and Hamilton County.)

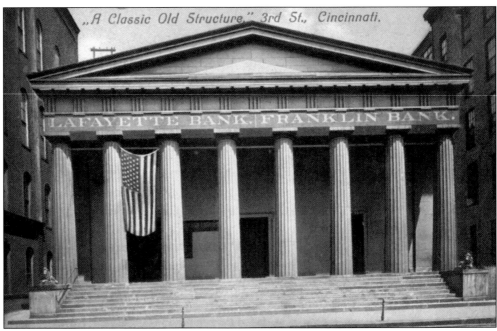

Henry Walter built the Lafayette and Franklin Bank Building on Third Street in 1840. Included was a tunnel leading to the river, used for transporting bullion. This was put to an even better use when the tunnel was made part of the Underground Railroad. (From the Collection of the Public Library of Cincinnati and Hamilton County.)

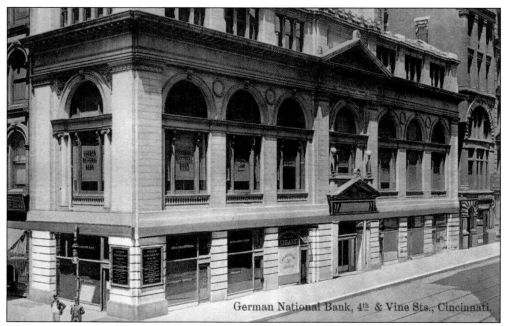

The German National Bank building at Fourth and Vine Streets looks more French than German. The building was constructed in 1904 in the Beaux Arts style, inspired by the Bibliothèque Sainte-Geneviève. Due to anti-German prejudice during World War I, the name was changed to the Lincoln National Bank. (From the Collection of the Public Library of Cincinnati and Hamilton County.)

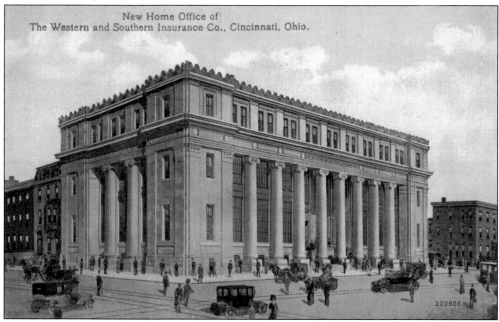

This is the home of one of the nation's largest insurance companies, Western & Southern Life. It is strange to think that an underwriter may now have a desk on the very spot where Charles Dickens slept. Before this building was constructed in 1916, this was the location of the Dexter mansion. (From the Collection of the Public Library of Cincinnati and Hamilton County.)

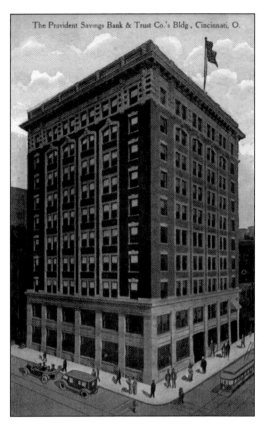

The Provident Savings Bank & Trust Co.'s Bldg., Cincinnati, O.

This 11-story building was completed in 1909 and still graces the corner of Seventh and Vine Streets. The Provident Bank was one of Cincinnati's leading financial institutions. It became part of Cleveland's National City in 2004 and was later acquired by PNC. (From the Collection of the Public Library of Cincinnati and Hamilton County.)

Located at 209 West Seventh Street, this was one of the busiest telephone offices in the country, with the world's longest straight line of long distance switchboard operators. On January 23, 1937, in the midst of the Ohio River's worst flood, 9,722 long-distance calls went through the office. (From the Collection of the Public Library of Cincinnati and Hamilton County.)

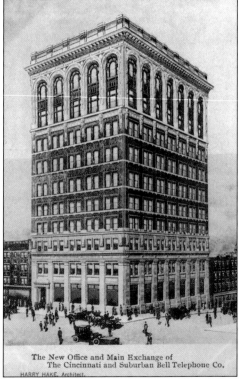

The New Office and Main Exchange of
The Cincinnati and Suburban Bell Telephone Co.
HARRY HAKE, Architect.

THE BIG STORE'S GUARANTEED CLOTHING.

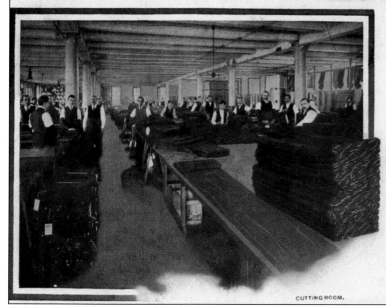

CUTTING ROOM.

All The Big Store's Clothing is manufactured under the direct supervision of the firm and kept in good repair and pressed for one year free of charge, and guaranteed in every respect absolutely.

D.L. Liebman's Big Store, founded in 1896, was one of the most popular downtown stores. It specialized in men's and women's clothing, as well as haberdashery. It was one of the few department stores to feature a beauty salon on premises. (From the Collection of the Public Library of Cincinnati and Hamilton County.)

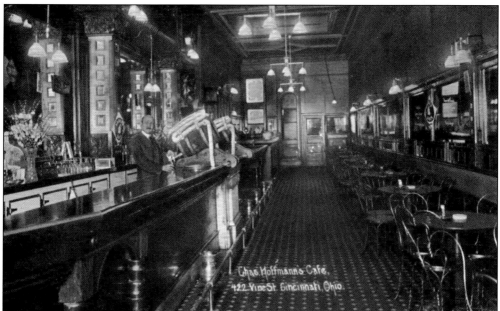

The bartender is ready to take orders. This is an interior view of the Charles Hoffmann Café on Vine Street. This area featured a number of elegant taverns, including Foucar's and the Mecca, where Boss Cox held court. (From the Collection of the Public Library of Cincinnati and Hamilton County.)

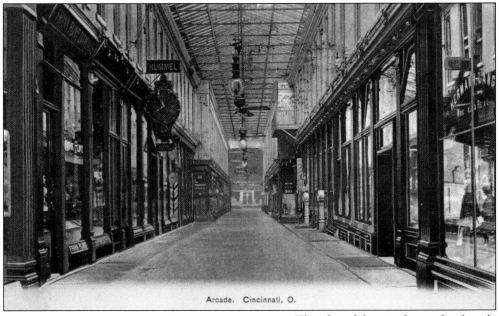

Arcade. Cincinnati, O.

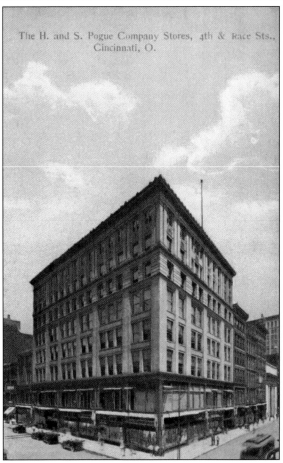

The H. and S. Pogue Company Stores, 4th & Race Sts.,
Cincinnati, O.

The idea of the arcade was developed in the Palaise-Royal in Paris in 1784. The Carew Tower arcade features an Art Deco display of Rookwood pottery with a color pattern of elegant black and gold. Shoppers once walked between two department stores, as well as smaller specialty shops. (From the Collection of the Public Library of Cincinnati and Hamilton County.)

In 1863, two Irish immigrant brothers, Henry and Samuel Pogue, began their dry-goods operation. The store hired Samuel Hannaford to design its Fourth Street building. L.S. Ayres eventually acquired the chain. The classic downtown store was closed in 1988. (From the Collection of the Public Library of Cincinnati and Hamilton County.)

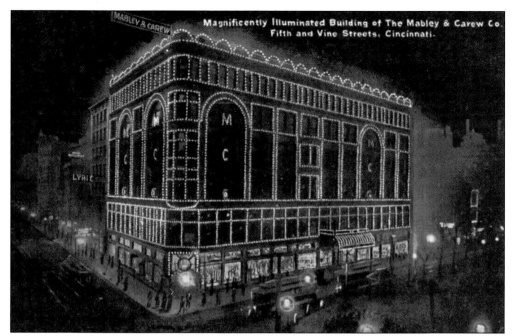

A simple bit of bad luck spawned a retail giant. Two Detroit businessmen, Joseph Carew and C.R. Mabley, were travelling south to Memphis when they missed their connection in Cincinnati. Wandering about Fifth Street, they found a store for rent and decided not to go to Tennessee. (From the Collection of the Public Library of Cincinnati and Hamilton County.)

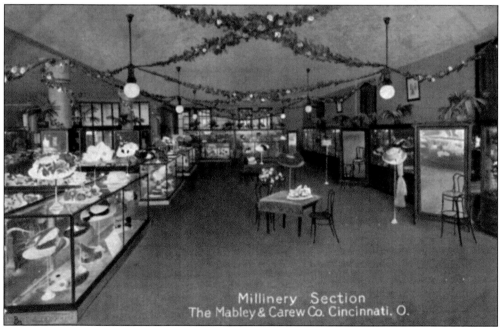

In the first half of the 20th century, shopping was a formal affair. No proper woman would ever consider going shopping without being attired in a hat and gloves. Many of those were purchased here, in the Millinery Section of Mabley and Carew. (From the Collection of the Public Library of Cincinnati and Hamilton County.)

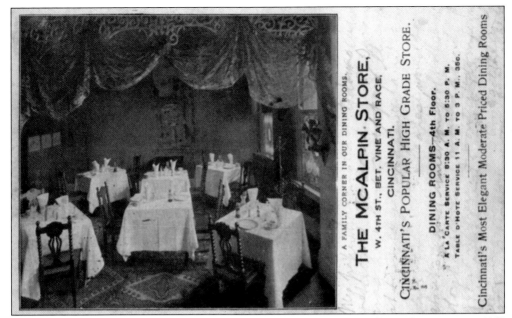

A FAMILY CORNER IN OUR DINING ROOMS.

THE McALPIN STORE,
W. 4TH ST., BET. VINE AND RACE,
CINCINNATI.

CINCINNATI'S POPULAR HIGH GRADE STORE.

DINING ROOMS—4th Floor.

A LA 'CARTE SERVICE 8:30 A. M. TO 6:30 P. M.
TABLE D'HOTE SERVICE 11 A. M. TO 3 P. M., 35c.

Cincinnati's Most Elegant Moderate Priced Dining Rooms

One of the great department stores of downtown Cincinnati was McAlpin's. Beginning in 1852 as Ellis, McAlpin & Co., in 1880 it moved into its location on Fourth Street. In 1954, McAlpin's was the first to expand to the suburbs. In 1996, the downtown store closed forever. (From the Collection of the Public Library of Cincinnati and Hamilton County.)

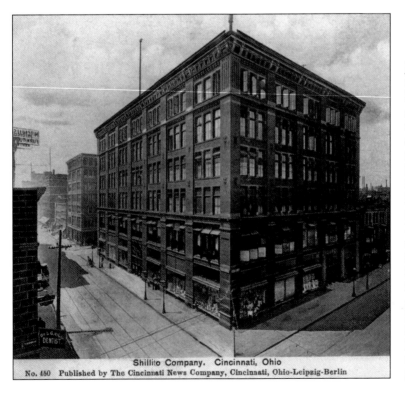

Shillito Company. Cincinnati, Ohio
No. 450 Published by The Cincinnati News Company, Cincinnati, Ohio-Leipzig-Berlin

John P. Shillito and William McClaughlin opened the very first modern department store in Cincinnati in 1832 on Fourth Street. McClaughlin left the partnership in 1857. In 1878, the store was moved to Seventh and Race Streets. The chain is now operated under the Macy's brand. (From the Collection of the Public Library of Cincinnati and Hamilton County.)

You are earnestly requested to call and examine my stock of Art Curios, etc.

I have an excellent line of goods suitable for Wedding Presents and Euchre Prizes, at most reasonable prices.

I also call your attention to my Tea and Coffee department. The Japanese Tea House shown herewith was the original exhibit at the St. Louis Exposition and was purchased by me at a great expense.

An early call will be greatly appreciated.

Yours truly,

PERMANENTLY LOCATED
21 W. 7TH STREET, CINCINNATI.

M. SUGIMOTO.

Apparently, Mr. Sugimoto was a firm believer in the old salesman's adage, "You gotta tell 'em to sell 'em." The image here depicts sophistication and the mysterious orient, popular themes in Victorian times. The exotic Tea House doubtlessly made shopping with Mr. Sugimoto a memorable experience. (From the Collection of the Public Library of Cincinnati and Hamilton County.)

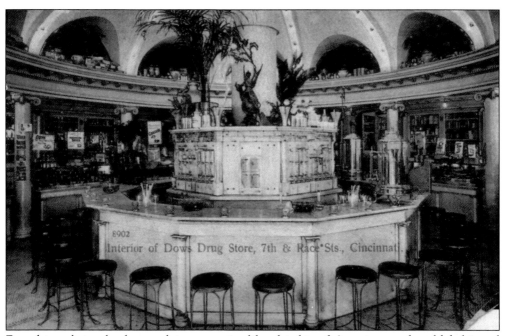

Few things bring back nostalgic memories like this bit of Americana: the old-fashioned drugstore soda fountain. This one in Dow's Drugstore, located a bit uptown at Seventh and Race Streets, was particularly ornate. (From the Collection of the Public Library of Cincinnati and Hamilton County.)

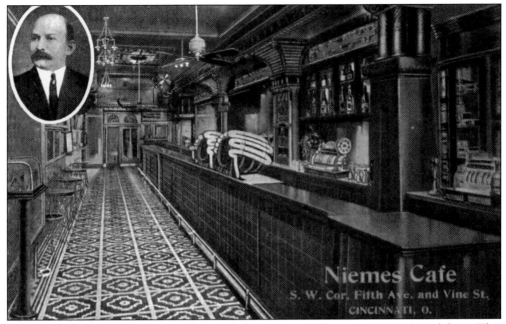

The Niemes Café on Vine Street advertised that it carried Cincinnati's own Hauck beer. This was "direct from wood to you—pure, cold and sanitary." Here, two kegs of Hauck beer can be seen mounted on the bar, waiting for a thirsty patron. (From the Collection of the Public Library of Cincinnati and Hamilton County.)

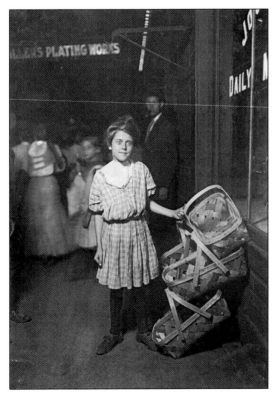

Paper, plastic . . . or wicker? Twelve-year-old Antoinette Siminger of Price Hill would join many other children on Saturdays at the Sixth Street Market. Anoinette's day would start very early and continue until around 11:00 p.m. She has a smile on her face, because she is nearly sold out. It is almost time to go home. (Library of Congress LC-DIG-ndc-03198.)

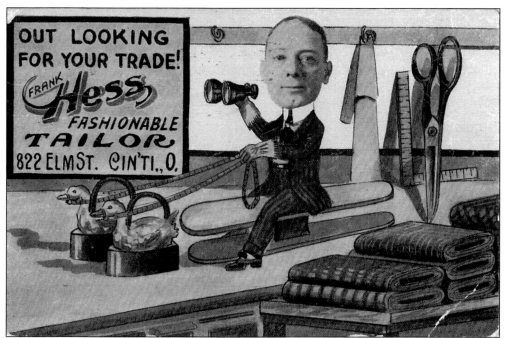

Besides giant companies such as Procter & Gamble, and large department stores such as Shillito's and Pogue's, downtown Cincinnati was also home to numerous small businesses that competed for customers. Frank Hess's tailor shop may have been a bit uptown from the major shopping district, but he was certainly determined that people would remember him. (From the Collection of the Public Library of Cincinnati and Hamilton County.)

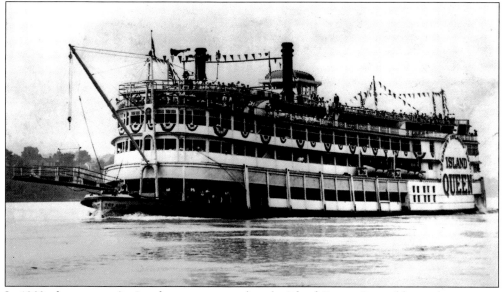

In 1902, the steamer *St. Joseph* was resurrected as the *Island Queen*. It would soon become one of Cincinnati's most popular businesses. This vessel would pick up its passengers in downtown Cincinnati and transport them upriver to the Coney Island Amusement Park. For nearly half a century, it carried Cincinnatians off for a day of pleasure and relaxation. (From the Collection of the Public Library of Cincinnati and Hamilton County.)

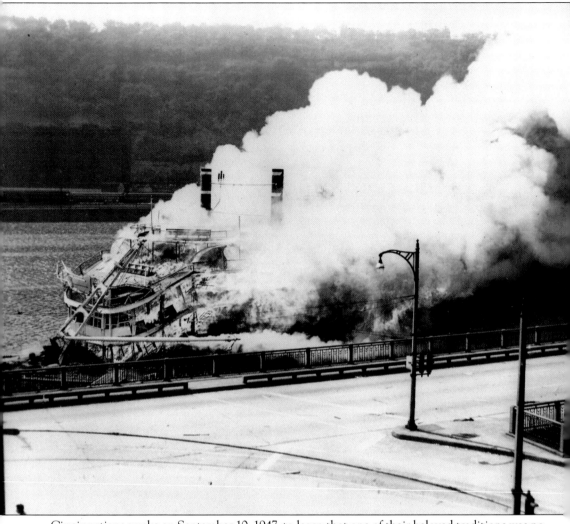

Cincinnatians awoke on September 10, 1947, to learn that one of their beloved traditions was no more. Over the years, the *Island Queen* suffered numerous accidents. It survived the ice flow of 1918, but its sister ship *Princess's* hull was crushed. In 1922, the first *Island Queen* was destroyed when the steamboat *Morning Star*, also docked in downtown Cincinnati, caught fire and ignited a load of roofing tar. Two other steamboats burned as well. In 1947, the second *Island Queen* was undergoing repairs in Pittsburgh. The chief engineer, Fred Dickow, lit a welding torch and inadvertently caused an explosion, killing 19 and wounding 18 others. The ensuing fire, shown here, destroyed the beloved boat, thus terminating its career as the Coney Island shuttle. (From the Collection of the Public Library of Cincinnati and Hamilton County.)

Three

LAW, ORDER, AND DISORDER

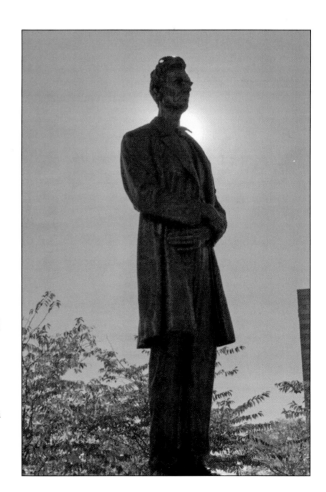

A lawyer came upon a garden with an old man working in it. He asked if he could enter the grounds. The gardener growled that he usually charged, but he would let this man in for free. The gardener was Nicholas Longworth, owner of the mansion. The lawyer was Abraham Lincoln, who was later honored with this statue in Lytle Park across the street. (Photograph by Doug Weise.)

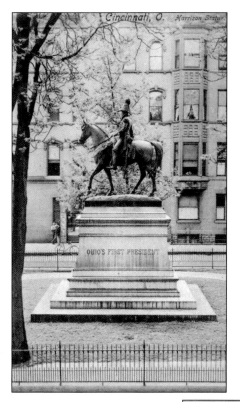

This is sculptor Louis T. Rebisso's depiction of Pres. William Henry Harrison. Harrison married Anna Symmes, daughter of Cincinnati's founder, John Cleves Symmes. One foot of the horse is raised, because Harrison had been wounded in battle. Vandals love the statues in Piatt Park—Harrison's sword has been stolen three times. (From the Collection of the Public Library of Cincinnati and Hamilton County.)

Although William Henry Harrison is honored by a statue in Cincinnati, the man's relationship with Cincinnati was not always harmonious. While an ensign at Fort Washington, he exacted military discipline on a discharged soldier. He then beat a deputy with a walking stick when he tried to arrest him. As punishment for his zeal, Harrison was locked up for a day—in McHenry's Tavern. (Library of Congress, LC-USZ62-31.)

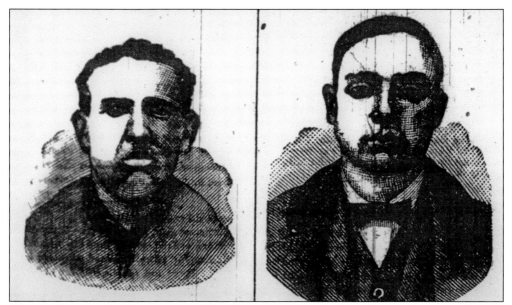

This rare drawing of William Berner and Joseph Palmer appeared in the *Cincinnati Commercial Gazette* on December 30, 1883. On Christmas Eve 1883, they murdered their employer, William Kirk. They agreed that whoever struck first would receive an extra $50. (Berner got the money.) Their act of violence would result in a massive riot, the burning of the courthouse, and a change in the political structure of the city. (From the collection of the Public Library of Cincinnati and Hamilton County.)

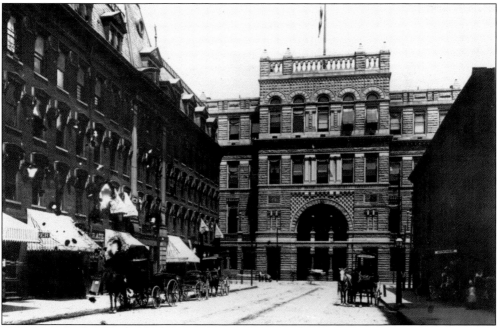

If there is a dividing line in the history of Cincinnati, it is the 1884 Courthouse Riot. Lawyer T.C. Campbell was able to have William Berner found guilty of mere manslaughter. When the verdict was announced, one old man in the courtroom shouted over and over, "Hang him!" Emotions in the city, already strained from two floods, erupted. (Courtesy of the Kenton County Library, Covington, Kentucky.)

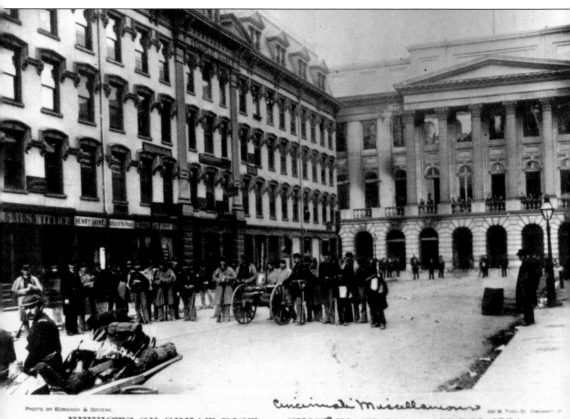

PHOTO BY ROMBACH & GROENE.

EFFECTS OF GREAT RIOT AT CINCINNATI, MARCH 28 & 29, 1884.

A meeting at Music Hall degenerated into a lynch mob that attacked the jail. Sheriff Lytle Hawkins had wisely removed Berner from the county. The rioters attacked the jail and later vented their fury by burning down the courthouse. At one point, the mob even managed to acquire a small cannon. They would not allow the fire department to approach the flaming building. The militia was summoned, but one regiment was driven away. The remaining forces had to use drastic action. After three nights of violence, the defenders finally ended the madness by firing a Gatling gun directly into the crowd. However, the automatic weapon, ironically invented by a Cincinnatian, had not been brought in by the militia. The military had borrowed the device from the Cincinnati police. (Courtesy of the Kenton County Library, Covington, Kentucky.)

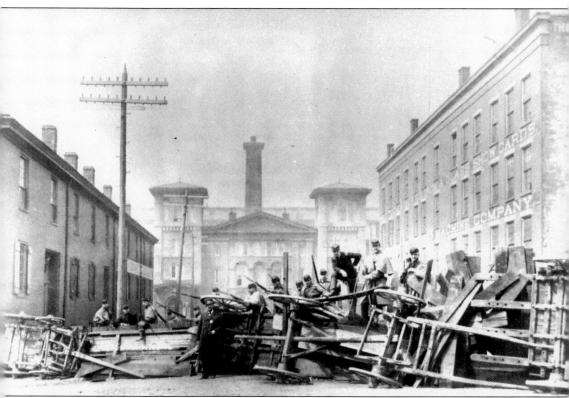

Amidst the violence, T.C. Campbell's elegant Avondale house was burned, thereby causing great damage to a collection of rare books. The jurors in the trial were assaulted, pelted by fruit as they were spirited away through a back door of the courthouse. A few had to flee town for their own safety. One lynch mob did manage to briefly penetrate the jail and looked right at Berner's accomplice, Joseph Palmer. They asked him if he was Palmer. The prisoner, who was of mixed race, replied, "No, can't you see that I'm a white man?" The mob simply continued on before being driven out by the sheriff's men. William Berner was convicted of a lesser charge, sentenced to just 20 years, and served only 12. After he was released, he moved to Indiana. (Courtesy of the Kenton County Library, Covington, Kentucky.)

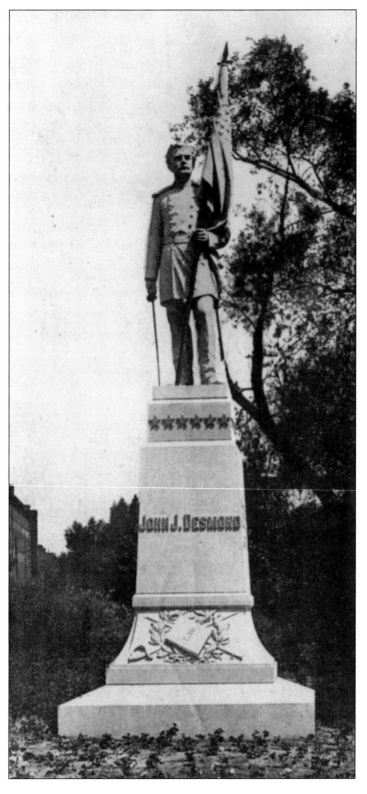

JOHN J. DESMOND

One of the many casualties of the riot, John Desmond, a Cincinnati lawyer and the captain of the 1st Ohio Militia Regiment, placed his men behind a hastily erected barricade of overturned wagons. The mob had stolen a supply of kerosene and other flammable substances, and soon they were hurling flaming missiles at the defenders. Amidst this barrage, some incendiaries were tossed into the law library and records office. As the flames ignited, Desmond now stood as a clear target. He was shot in the throat and died. This statue was placed in a park and later moved to the new courthouse. A small plaque also memorializes Captain Desmond. (From the Collection of the Public Library of Cincinnati and Hamilton County.)

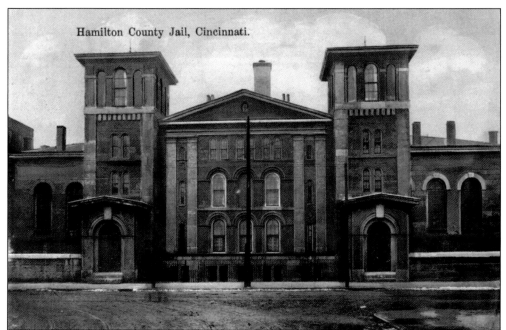

Hamilton County Jail, Cincinnati.

"Only one when it should have been two," proclaimed the newspaper when murderer Joseph Palmer was led into this courtyard and hanged. Palmer was the last man to be executed in Hamilton County. (From the Collection of the Public Library of Cincinnati and Hamilton County.)

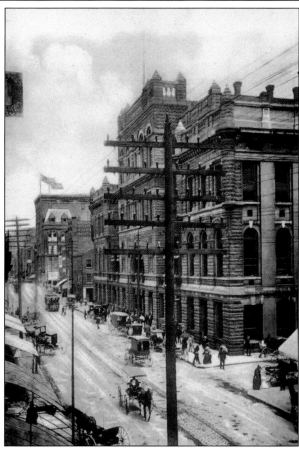

After using temporary facilities following the burning of the old courthouse during the riots, a new courthouse was finally built. Things very quickly returned to business as usual. There was one unexpected reform as a result of the riot: the new courthouse was fireproof. (From the Collection of the Public Library of Cincinnati and Hamilton County.)

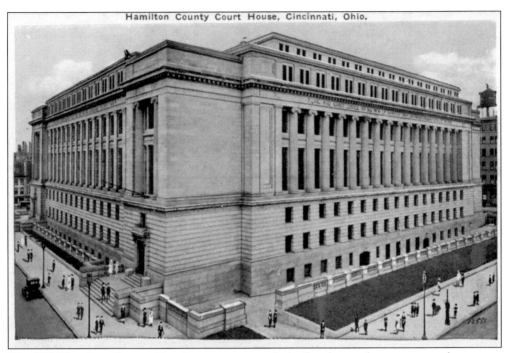

The 1919 Hamilton County Courthouse was opened, the fourth courthouse to serve the county. While it appears impressive and inspiring with its classical facade, a closer look reveals it to be more of a fortress with high, vertical windows. Like the one immediately preceding it, it was made of fireproof stone. (From the Collection of the Public Library of Cincinnati and Hamilton County.)

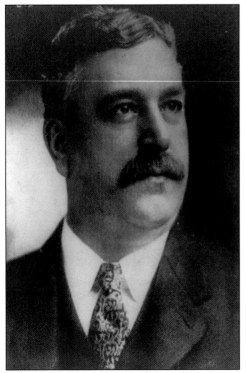

George Barnsdale Cox (1853–1916), an effective lieutenant of T.C. Campbell, rose to prominence after Campbell left town following the Courthouse Riot. Cox, known as "The Boss," became one of the most powerful political bosses in American history. He ran Cincinnati from a booth in Weilart's Biergarten and the downtown Mecca Saloon on Walnut Street. (Library of Congress, LC-USZ62-94995.)

Before he became the boss of the city, George Cox lived in this brownstone on Ninth Street within easy walking distance of City Hall. Later, when he achieved prominence, Cox would follow the dictates of upper society and leave the downtown area, purchasing a mansion in Clifton. (Photograph by Doug Weise.)

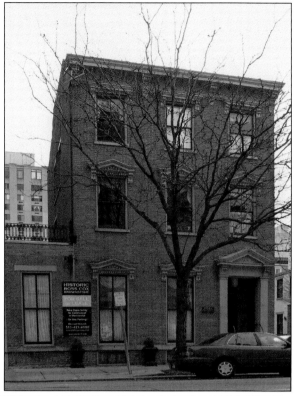

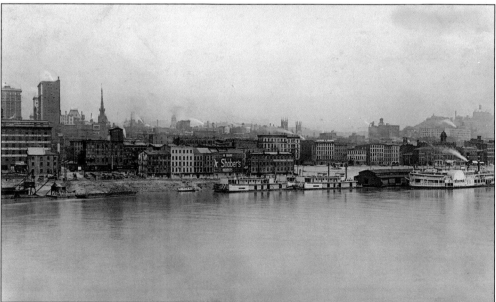

By 1912, the Cox Machine was in full control of downtown Cincinnati. Favorite son William Howard Taft would find himself facing his old boss Theodore Roosevelt for the presidency. By the next year, Taft would lose the White House to Wilson, and many downtown streets would be lost to the raging river. (From the Collection of the Public Library of Cincinnati and Hamilton County.)

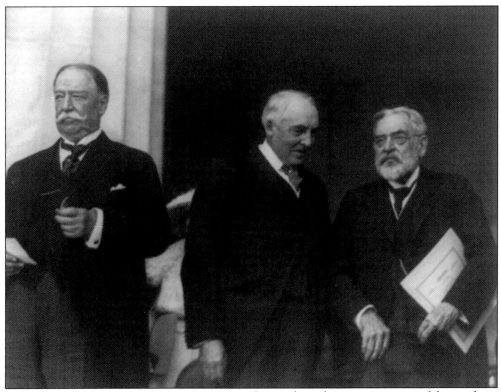

Pictured are the past, present, and future, from left to right: William Howard Taft, Warren G. Harding, and Robert Todd Lincoln. Taft found himself in the shadow of his old boss, Theodore Roosevelt, whom he referred to as "the man who formulated the expression of the popular conscience and who led the movement for practical reform." Later, Roosevelt would run against him as a Bull Moose Party candidate, splitting the vote. (Library of Congress, LC-USZ62-96487.)

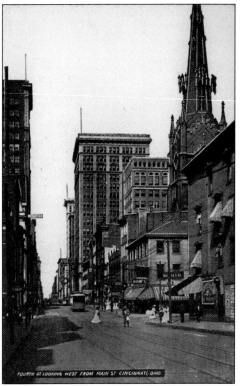

FOURTH ST LOOKING WEST FROM MAIN ST CINCINNATI, OHIO

In 1881, at Fourth and Vine Streets, a young woman named Nellie Stickeley was murdered by her boyfriend. The defense attorney was T.C. Campbell; the prosecutor was young William Howard Taft. Campbell won, but Taft never forgot his humiliation. Taft would battle against Campbell and later against the Cox machine. (From the Collection of the Public Library of Cincinnati and Hamilton County.)

Nellie Herron could look out of her upstairs window in this house and see the Longworth-Sinton mansion just across the street. Strong willed, she was a rebel who loved to shock people by drinking beer, working as a teacher, and speaking German. She conducted a salon, where young upper-class men and women met to discuss politics and culture. William Howard Taft was a member. (Library of Congress, LC-DIG-hec-00341.)

The Lombardy apartment building, designed by Samuel Hannaford, still stands on the far western end of Fourth Street. In the 1880s, the young lawyer and revenue collector William Howard Taft had an apartment here. Ironically, he was also just around the corner from the Deadman Saloon, owned for a while by his enemy, George Cox. This area of Fourth Street now houses art galleries. (Photograph by Doug Weise.)

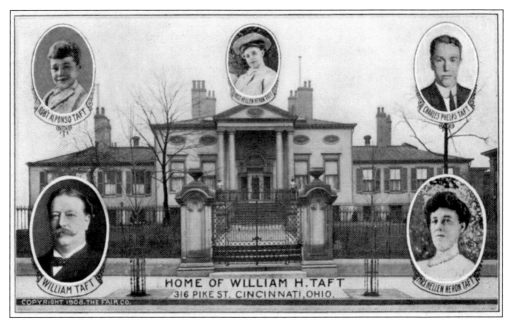

Despite the caption, this is not actually the home of William Howard Taft. In the lower right-hand corner is his wife, Helen "Nellie" Taft. While visiting her father's old law partner Rutherford B. Hayes at the White House, she determined that the man she would marry would some day become president. (From the Collection of the Public Library of Cincinnati and Hamilton County.)

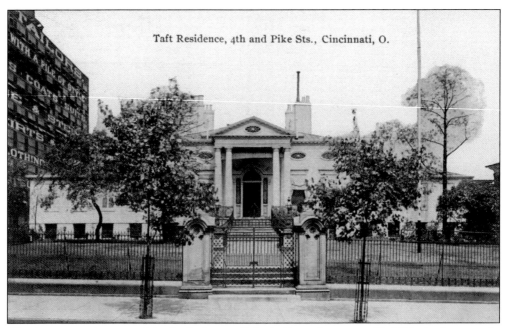

The elegant mansion was originally the home of Martin Baum, later owned by Nicholas Longworth. It was purchased by David Sinton, who made a fortune selling iron to the Union army during the Civil War. His daughter Annie married Charles Taft. The building is now the Taft Museum of Art. (From the Collection of the Public Library of Cincinnati and Hamilton County.)

When William Howard Taft stepped off of the train in Cincinnati, he was greeted by a poster of himself proclaiming, "No Place Like Home." Taft's charm made him likeable, even to political enemies. Governor Comer of Alabama sent his best wishes, stating, "I want to see Mr. Bryan elected, but with the least possible damage to Mr. Taft, as we like him." (Library of Congress, LC-DIG-ggbain-02021.)

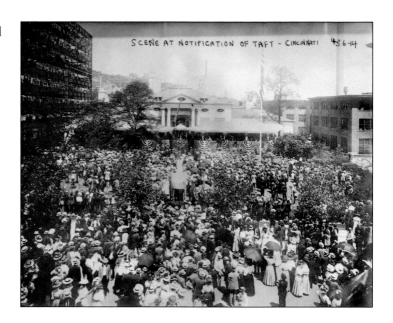

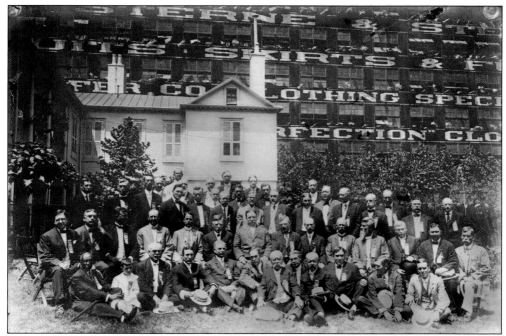

On the day of the notification, the candidate's wife, Helen, spent the day at the Sinton mansion talking with friends. When Taft formally received the nomination committee, he glanced back at his wife, who was standing at the top of the steps carefully watching the proceedings. With a determined and satisfied look, she returned his smile. (Library of Congress, LC-DIG-ggbain-02022.)

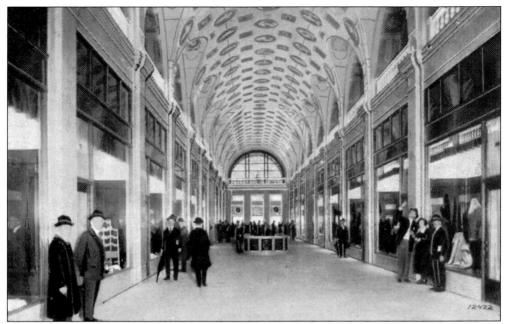

Civil War veterans flocked to Cincinnati to celebrate the encampment of the Grand Army of the Republic, held in Cincinnati in 1898. "The only national debt we can never pay is the debt of gratitude we owe our soldiers and sailors," proclaimed the *Enquirer*. (From the Collection of the Public Library of Cincinnati and Hamilton County.)

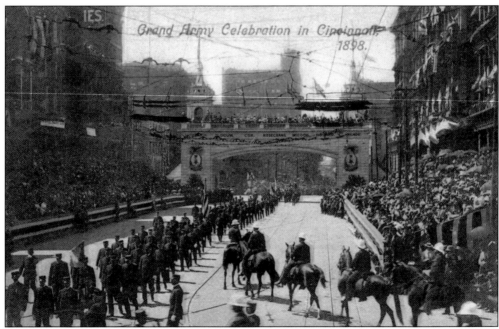

The police gave up trying to keep the young men and, shockingly, young women from walking across the Fifth Street arch erected for the parade for the GAR. As more and more young people congregated, the wait at the line to illegally cross Fifth Street from above was more than an hour. (From the Collection of the Public Library of Cincinnati and Hamilton County.)

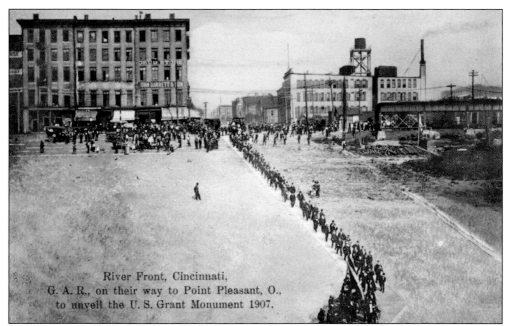

River Front, Cincinnati,
G. A. R., on their way to Point Pleasant, O.,
to unveil the U. S. Grant Monument 1907.

This 1907 image shows the disembarking from downtown Cincinnati of the GAR to Point Pleasant, the birthplace of their former commander. Parlor A in Cincinnati's Burnet House, where Grant and Sherman planned their endgame, became sacred ground. The Sons of Union Veterans would have a banquet there each year. (From the Collection of the Public Library of Cincinnati and Hamilton County.)

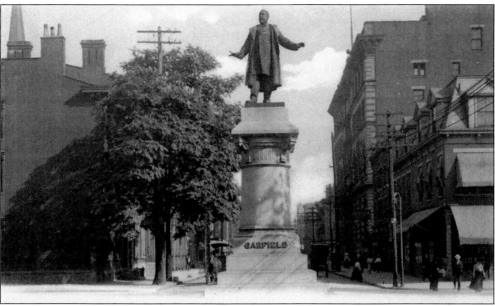

James Garfield had only served for a year before he was assassinated. When originally dedicated in 1887, his statue was placed in the dead center of the intersection of Race and Garfield Streets, where it immediately became a traffic hazard. It took 23 years before the city fathers got around to moving it into Piatt Park. (From the Collection of the Public Library of Cincinnati and Hamilton County.)

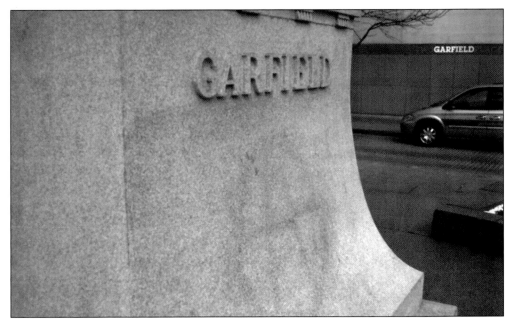

In 1883, sculptor Charles Niehaus was awarded the contract for the Garfield statue. In 1887, the monument was unveiled. Sadly, like the president, the statue was the victim of criminal activity. In June 1994, a vandal painted an anarchy symbol below the name, using paint that seeped into the stone. The outline of this idiocy is still visible. (Photograph by Jordan Rolfes.)

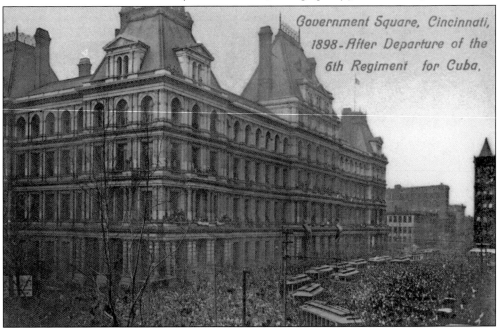

In 1898, the journey to war started downtown at Government Square when the 6th Regiment set off for the Spanish-American War. This short conflict had a profound effect upon one prominent Cincinnatian. William Howard Taft rose to national prominence when he was appointed governor of America's new colony: the Philippines. (From the Collection of the Public Library of Cincinnati and Hamilton County.)

America's entry into World War I spawned prejudice, even in the heavily German city of Cincinnati. Street names were renamed with more "patriotic" titles. Bremen Street, for example, became Republic. The Cincinnati Library was requested to remove every book written in German. German shepherds were now called "Alsatians." (From the Collection of the Public Library of Cincinnati and Hamilton County.)

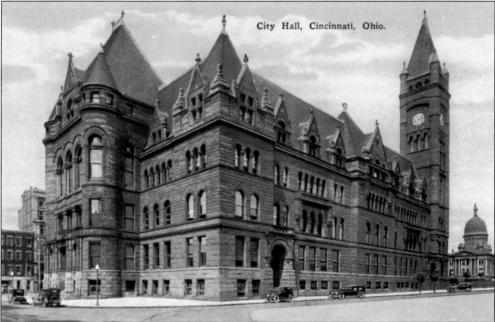

The City Hall on Plum is actually the second city hall built upon this site, the first built in 1852. One of the most distinctive features is a purple hue to some of the blocks. The noted Samuel Hannaford, who also designed Music Hall and Elsinore Castle, planned the building. (From the Collection of the Public Library of Cincinnati and Hamilton County.)

Cincinnati has had a number of unusual mayors, such as the controversial television host Jerry Springer. In 1875, Mayor Johnston conducted the "real business" in a back room equipped with barrels of cheese, crackers, and beer. The most unusual man to occupy the office was Robert Moore, who liked to carry roses in his teeth. (From the Collection of the Public Library of Cincinnati and Hamilton County.)

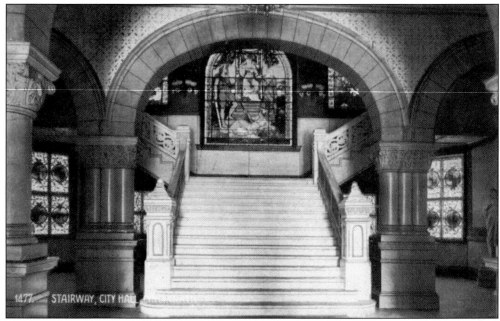

Here is a 1908 view of the marble staircase in Cincinnati's City Hall. Sadly, most of the Pedretti murals above have long since been painted over; however, the windows remain. There are numerous stained-glass windows scattered throughout the building complex. (From the Collection of the Public Library of Cincinnati and Hamilton County.)

"The Queen of the West / In her garlands dressed / On the banks of the Beautiful River." This segment of the poem "Catawba Wine" not only describes downtown Cincinnati, but also earned Longfellow a place of prominence on the stained-glass window in City Hall. Notice how both apples and the definitive Ohio symbol, buckeyes, surround the queen. (Photograph by Doug Weise.)

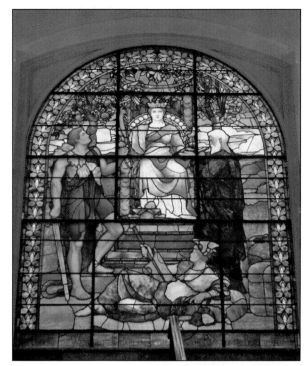

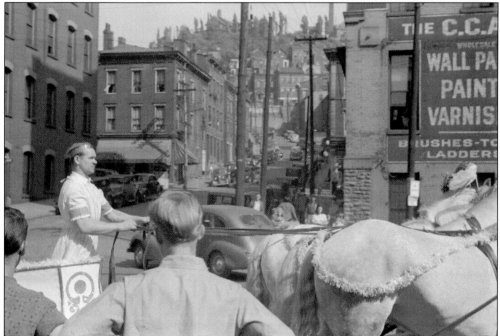

One can never find a parking space downtown! While Government Square is the hub of public transportation in downtown Cincinnati, one does not usually see a chariot. This is from the sesquicentennial parade, depicting Cincinnati's connection to Rome. Eden Park in Mount Adams features a famous statue of Romulus and Remus being nursed by the wolf—a gift from the city of Rome. (Library of Congress, LC-USF33-T01-001211-M3.)

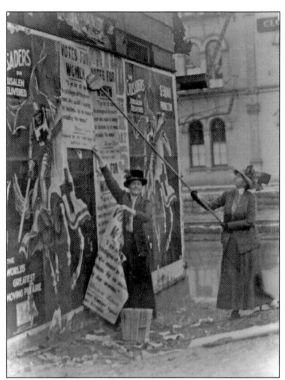

Suffragettes Louise Hall and Susan Fitzgerald post their information on a downtown street in 1912. The issue was debated mainly through women's clubs. The Progressives and the "Stand Patters" battled each other from podiums. Archbishop Henry Moeller opposed women voting, fearing that the vote "will bring women into a sphere of activities not in accord with their retiring modesty, maidenly dignity and refinement." (Library of Congress, LC-USZ62-22260.)

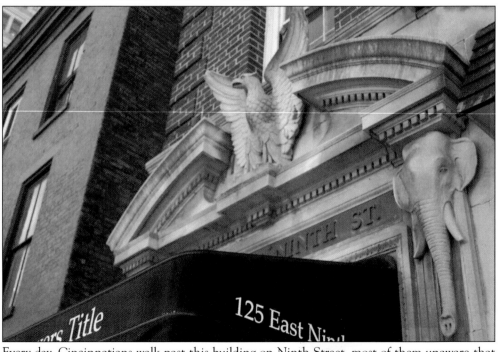

Every day, Cincinnatians walk past this building on Ninth Street, most of them unaware that there are elephants watching them. This was once the headquarters for the Republican Party in Hamilton County. An American eagle proudly perched over the door tops the symbols of the party. (Photograph by Jordan Rolfes.)

Four

ARTS AND LEISURE IN DOWNTOWN CINCINNATI

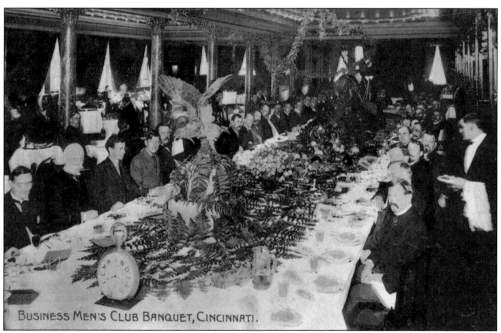

BUSINESS MEN'S CLUB BANQUET, CINCINNATI.

As Cincinnati ascended to a place of national prominence in the world of business and the arts, downtown was the place to go to celebrate, conduct banquets, or simply to "step out." Amidst the banks and stores were a large number of cafés, saloons, and fine theaters ready to refresh or entertain downtown visitors. (From the Collection of the Public Library of Cincinnati and Hamilton County.)

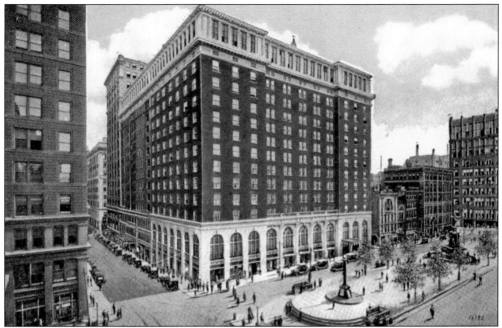

Here is the esplanade of Fountain Square with the Johnston Building and the Hotel Gibson. The various styles made an impression on one visitor. In his 1831 *Journey to America*, Alexis de Tocqueville descried downtown Cincinnati as an "odd spectacle" and "a town that wants to get built too quickly to have things done in order." (From the Collection of the Public Library of Cincinnati and Hamilton County.)

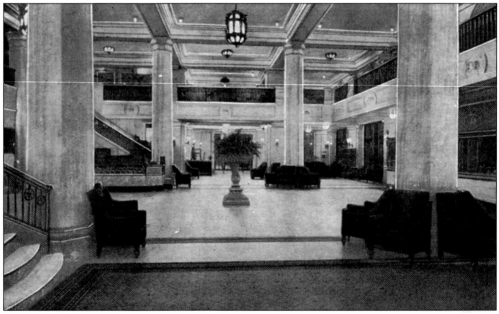

In 1849, Peter Gibson raised laughter with his idea of building a luxury hotel up in the remote area of Fifth Street. However, by the 1860s, the center of town had moved away from the river and right up to him. One of his innovations was a staircase that led to every floor. (From the Collection of the Public Library of Cincinnati and Hamilton County.)

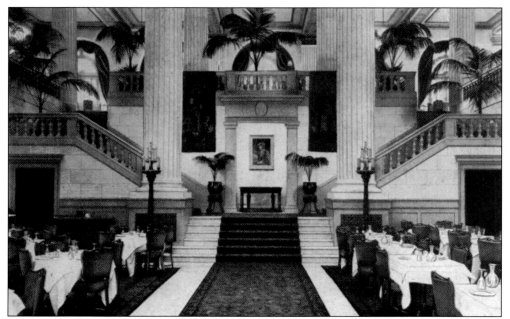

The Hotel Gibson featured artwork by the prominent artist William A. Thien. It was even used as an internment location for German prisoners during World War II. Eventually, the hotel was acquired by the Sheraton Company and renamed the Sheraton-Gibson. In the 1970s, this once-proud hotel was demolished. (From the Collection of the Public Library of Cincinnati and Hamilton County.)

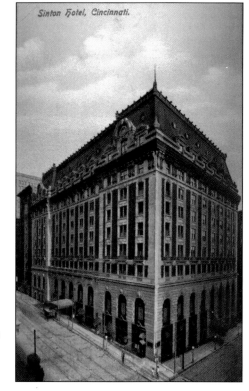

Irish immigrant David Sinton was a shrewd businessman. Seeing the Civil War coming, he bought up stockpiles of pig iron, which he later sold to the government to supply the Union army. Sinton was involved in many ventures, including building an exposition center and this opulent high-rise hotel. (From the Collection of the Public Library of Cincinnati and Hamilton County.)

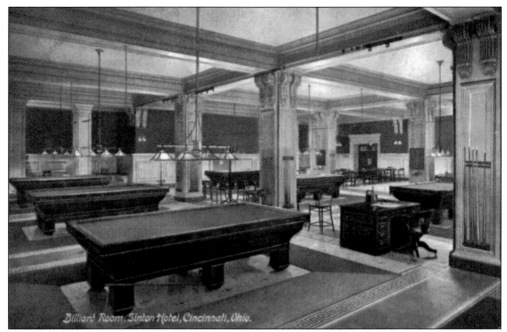

One can only wonder how many important business deals were made here with a glass of brandy in one hand and a billiard stick in the other. Note the pockets on the tables, as this is the more refined game of billiards. (From the Collection of the Public Library of Cincinnati and Hamilton County.)

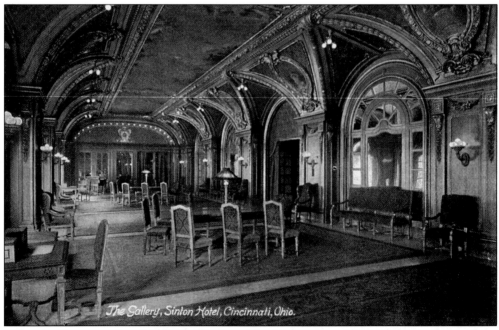

When the Sinton was demolished, the Cincinnati Art Museum was able to pick up some significant works of art. Among these is the Vouet painting *The Toilet of Venus*. During restoration, it was discovered that the artist had originally painted her in the nude. The work is now displayed as originally intended. (From the Collection of the Public Library of Cincinnati and Hamilton County.)

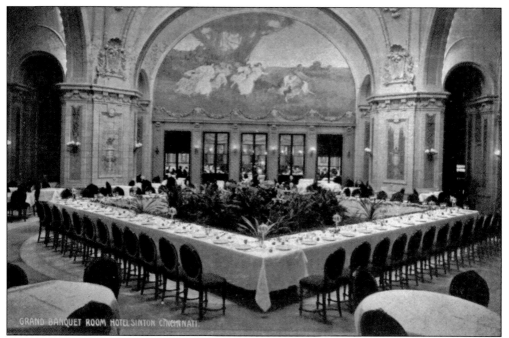

One would have to look very hard to find more elegant surroundings than the Sinton Hotel for a business or social banquet. Artist John Dee Wareham's Rookwood tiles depicting the four seasons was destined to adorn the walls of the Cincinnati Art Museum's restaurant, the Terrace Court. (From the Collection of the Public Library of Cincinnati and Hamilton County.)

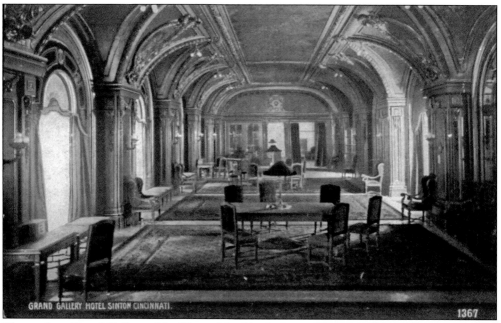

The opulent Grand Gallery of the Sinton Hotel looked more like a corridor in a European palace than a Midwestern American hotel. (From the Collection of the Public Library of Cincinnati and Hamilton County.)

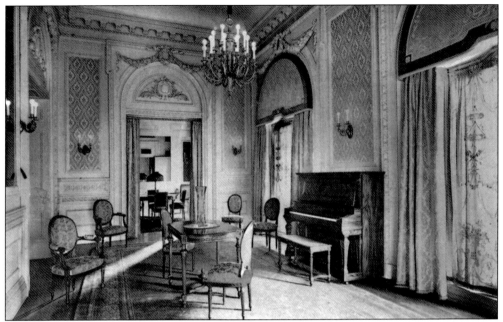

Here is the Bridal Reception Room of the Hotel Sinton, all ready for the fashionable young woman on her special day. (From the Collection of the Public Library of Cincinnati and Hamilton County.)

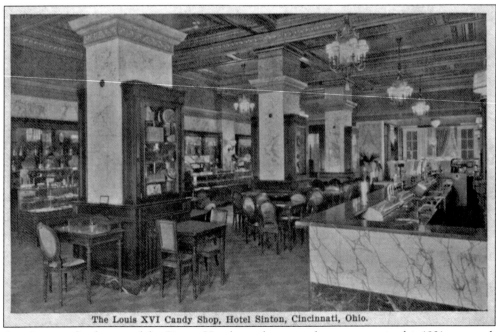

The Louis XVI Candy Shop, Hotel Sinton, Cincinnati, Ohio.

Another popular feature of the Sinton Hotel was the sweet shops, as seen in this 1921 postcard. This tempting shop was named after the French monarch Louis XVI. (From the Collection of the Public Library of Cincinnati and Hamilton County.)

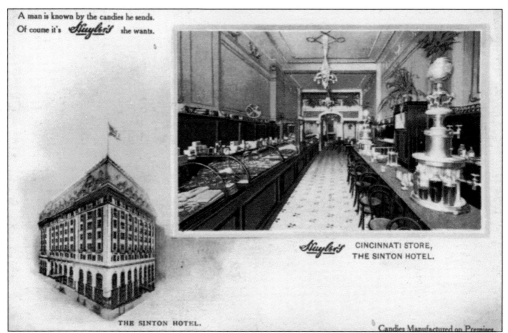

A man is known by the candies he sends.
Of course it's *Huyler's* she wants.

Huyler's CINCINNATI STORE,
THE SINTON HOTEL.

THE SINTON HOTEL.

Candies Manufactured on Premises

There was another sweet shop in the Sinton Hotel, the elegant Huyler's. The postcard reminds the gentleman that he is known by the candy he sends, and that Huyler's manufactures its candy right on the premises. (From the Collection of the Public Library of Cincinnati and Hamilton County.)

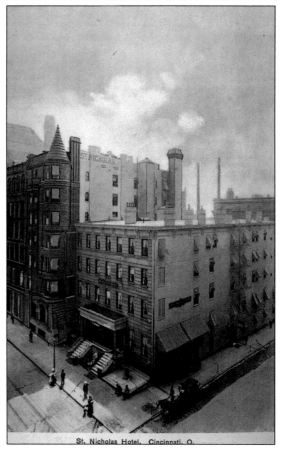

St. Nicholas Hotel, Cincinnati, O.

The most luxurious lodgings in downtown were to be found at the tiny St. Nicholas Hotel at Fourth and Race Streets. It gained a worldwide reputation since its opening in 1865. The manager, Balthazar Roth, was fanatical about providing the finest quality. The hotel closed in 1911, and the name "St. Nicholas" was quickly purchased by the Sinton Hotel. (From the Collection of the Public Library of Cincinnati and Hamilton County.)

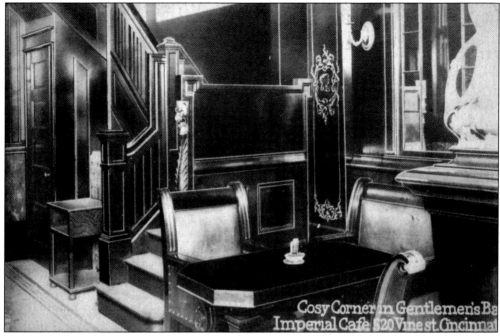

Cosy Corner in Gentlemen's Ba Imperial Café 520 Vine st. Cincinnat

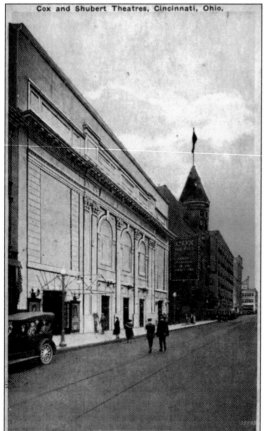

Cox and Shubert Theatres, Cincinnati, Ohio.

Here is a view of the interior of the elegant Imperial Café on Vine Street, near Fountain Square. Referred to as a "gentlemen's bar," here many businessmen and politicians would meet to discuss events and make deals. (From the Collection of the Public Library of Cincinnati and Hamilton County.)

George B. Cox was a devotee of the theater. Although he died in 1916, his legacy was immortalized in a theater on Seventh Street. Right next to the Schubert, the Cox remained a landmark until the 1950s. While other vaudeville theaters were converted to movie houses, the Cox remained a venue for live performances. (From the Collection of the Public Library of Cincinnati and Hamilton County.)

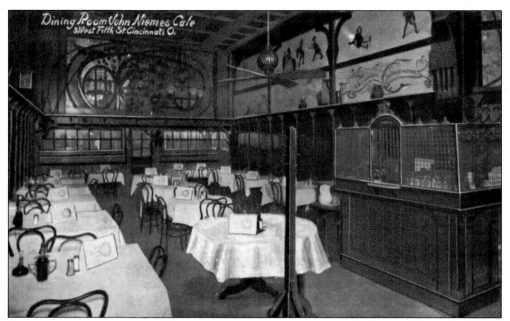

Many downtown visitors would have lunch in this fine dining establishment. The John Niemes Café was located right across the street from the Square near Vine Street. (From the Collection of the Public Library of Cincinnati and Hamilton County.)

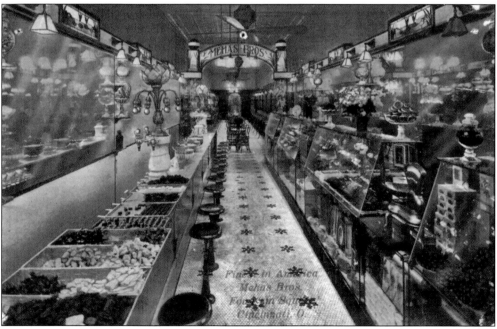

Declaring itself to be the "finest in America," the Mehns Brothers confectionary on Fountain Square was for many years a popular destination for downtown shoppers. (From the Collection of the Public Library of Cincinnati and Hamilton County.)

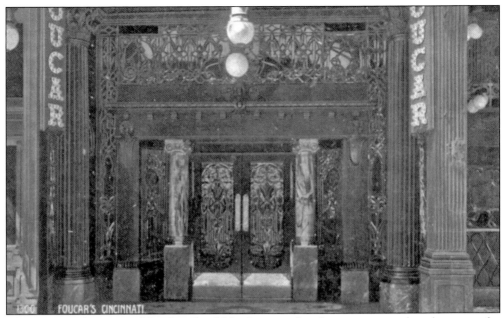

These ornate doors seem like they should lead into a church or a museum, but they were the entrance to a saloon! Foucar's on the Fountain was one of the most elegant drinking establishments in downtown Cincinnati. Here, one could see a number of prominent Cincinnatians, including the renowned artist Frank Duveneck, a regular patron. (From the Collection of the Public Library of Cincinnati and Hamilton County.)

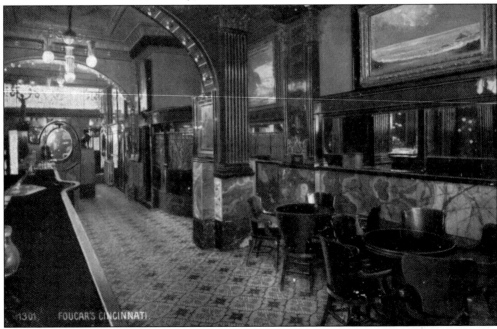

Foucar's was lined with 25 paintings, including works of prominent local artists Joseph Sharp and Henry Farney. Frank Duveneck, Cincinnati's most famous artist, had a number of works on display here. One piece, *Siesta* (commonly called *Foucar's Nude*), is in the collection of the Cincinnati Art Museum. (From the Collection of the Public Library of Cincinnati and Hamilton County.)

Garfield Place, Cincinnati, O.

The name Piatt Park honors John and Benjamin Piatt, who donated the land for an open-air market in 1817. However, unlike Fountain Square, a market has never stood there. The park is a relaxing place to have an outdoor lunch on a spring day or play a game of chess. (From the Collection of the Public Library of Cincinnati and Hamilton County.)

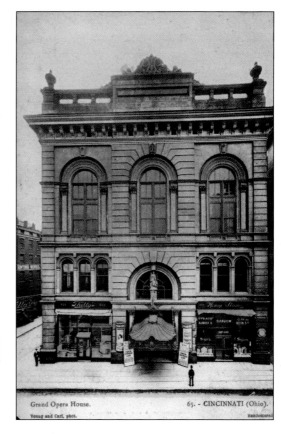

Grand Opera House. 65. - CINCINNATI (Ohio).

A favorite downtown destination during the Gilded Age, the Grand Opera House was located on Vine between Fifth and Sixth Streets. Built by David Sinton, the venue played host to a variety of stage and musical productions. The theater operated successfully until 1901, when it was destroyed by a fire. (From the Collection of the Public Library of Cincinnati and Hamilton County.)

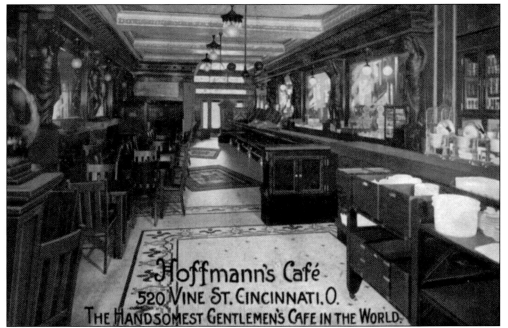

One certainly did not have to go far to find a drink while visiting Fountain Square. Here is yet another drinking establishment, this one on Vine Street, declaring itself to be "the handsomest gentlemen's café in the world." (From the Collection of the Public Library of Cincinnati and Hamilton County.)

Originally known as the Fountain Theater in 1899, this venue became the Columbia. It hosted some of the finest acts in the country, including Lillian Russell. It is where Elbert Hubbard tried to make a vaudeville debut. He was booed off the stage and was on a train out of the city that very night. (From the Collection of the Public Library of Cincinnati and Hamilton County.)

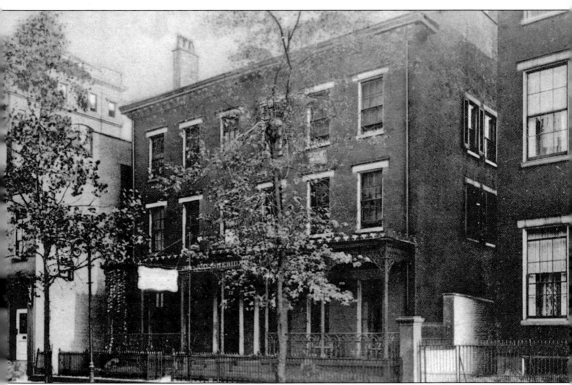

"Still sprang from those swift hoofs, thundering south, the dust like smoke from the cannon's mouth, or the trail of a comet, sweeping faster and faster, foreboding to traitors the doom of disaster." These verses are an excerpt from T. Buchanan Read's famous Civil War poem "Sheridan's Ride," written here on Eighth Street in 1864. (A plaque on the wall across the street from the library marks the spot.) Besides being a noted poet, Read was also a celebrated painter and, during hard times, a cigar maker. His most famous painting, *The Harp of Erin*, is an allegorical depiction of the Irish people as a harp-playing maiden chained to a rock. It is one of the most famous paintings permanently on display in the Cincinnati Art Museum. (From the Collection of the Public Library of Cincinnati and Hamilton County.)

Memorialized by a plaque on Race Street, in the late 1940s a surprising number of popular artists recorded their finest work in downtown Cincinnati. Radio station WLW featured numerous country-and-western acts, many of whom were persuaded to take a quick walk around the corner and visit WLW engineer "Bucky" Herzog's recording studio. Among the great songs recorded there were Flatt and Scrugg's "Foggy Mountain Breakdown," and in 1948, Hank Williams's classic "I'm So Lonesome I could Cry." King Records would occasionally send rhythm and blues artists downtown to record at Herzog's. Among those who made great music in downtown Cincinnati were such notables as Patti Page, Grandpa Jones, and the Delmore Brothers with their rockabilly classic "Freight Train Boogie." The studio later moved to Mount Adams, where it closed in 1955. (Photograph by Jordan Rolfes.)

Five

COMING AND GOING IN DOWNTOWN CINCINNATI

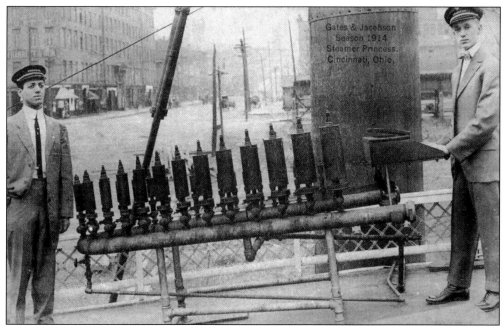

Nothing captures the excitement and romance of the old steamboat days quite like the shrill and lively music of a steam calliope. Here we see the distinctive riverboat concert being performed when the steamboat *Princess* docked in Cincinnati in 1914. (From the Collection of the Public Library of Cincinnati and Hamilton County.)

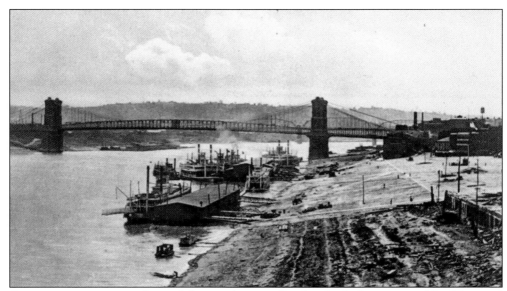

Cincinnati is approximately equal distance between Pittsburgh, the beginning of the Ohio, and Cairo, Illinois, the entrance to the Mississippi. In the background is the new suspension bridge, bringing traffic to the city with no danger of freezing or flooding. The landing itself is now a parking lot. (From the Collection of the Public Library of Cincinnati and Hamilton County.)

The Canal

31. - CINCINNATI. Ohio

Young and Carl, phot.

HANDCOLORED

This is a deceptively idyllic view of the Miami Erie Canal, which began its operation in 1827 and had its busiest year in 1851. By the closing decades of the 19th century, with the ascendancy of the railroads, canals were obsolete. In 1919, the man-made waterway was finally drained and filled in. (From the Collection of the Public Library of Cincinnati and Hamilton County.)

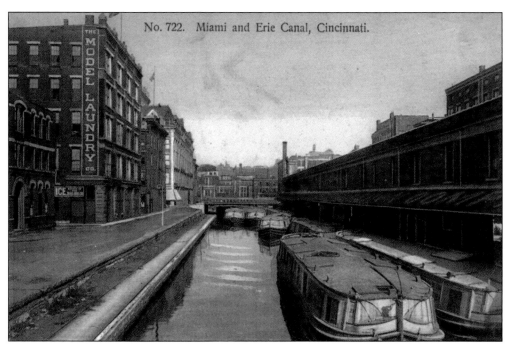

It is interesting to note that the pathway of the Miami-Erie Canal roughly followed the route of Gen. Anthony Wayne as he left Fort Washington in 1793. His campaign ended in the Battle of Fallen Timbers. The canal reached the Ohio River at the bottom of Eggleston Avenue in eastern downtown. (From the Collection of the Public Library of Cincinnati and Hamilton County.)

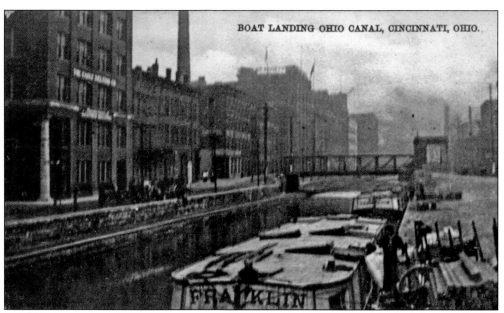

"This cesspool in our midst" was how Archbishop Moeller described the Miami-Erie Canal. After its heyday in the 1850s, the "Rhine" deteriorated into a floating garbage–strewn pool. This did not stop boys from making it a swimming hole in the summer and an ice skating rink when it froze during winter. (From the Collection of the Public Library of Cincinnati and Hamilton County.)

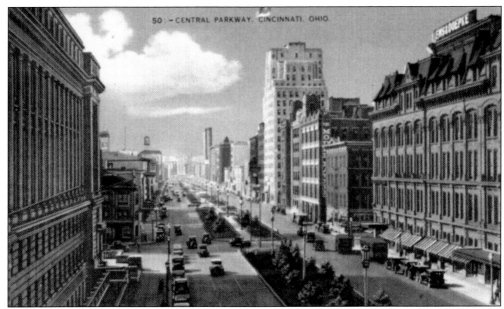

The 1920s brought many changes to downtown Cincinnati. The watery eyesore on downtown's northern border disappeared when the canal was at last filled in. In the space below was the infamous Cincinnati Subway. More efficient was the top, a modern road, Central Parkway. Today, it is one of Cincinnati's most picturesque highways. (Courtesy of the Kenton County Library, Covington, Kentucky.)

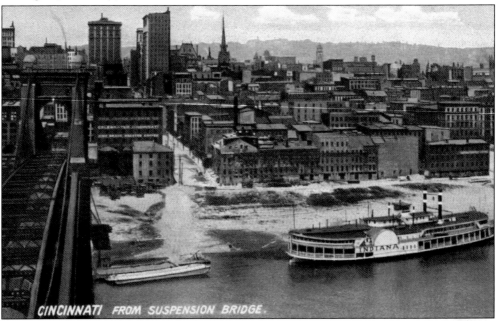

CINCINNATI FROM SUSPENSION BRIDGE.

The river, so vital to the economy of the city, was subject to floods, droughts, and even ice. In 1856, Pennsylvania engineer John Roebling started work on a suspension bridge that would connect Cincinnati to Kentucky. After a decade of battling politicians, investors, and labor shortages brought on by the war, the bridge was finally opened. (From the Collection of the Public Library of Cincinnati and Hamilton County.)

Cincinnatians were proud of their new bridge. It should come as no surprise that after waiting an entire decade, suffering the stress of the nation's worst war, it was time for a little festivity. In a blending of technology and art, the celebrants were treated to a rousing commemorative musical piece, "The Suspension Bridge March." At least it wasn't a waltz! (Library of Congress, LC-USZ62-7924.)

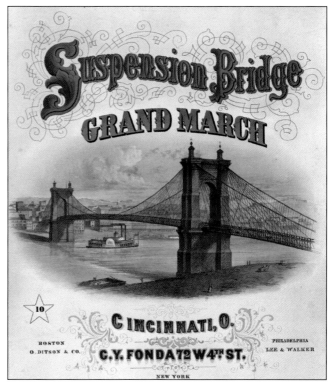

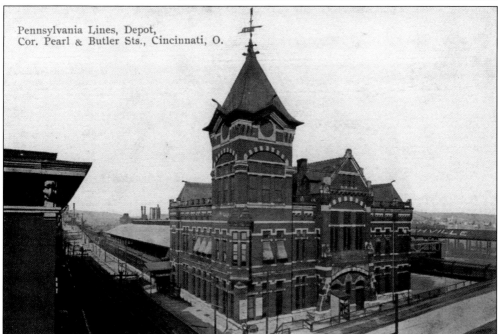

Looking a bit like a gingerbread house, this was the station of the Pennsylvania Line on Pearl Street. Individual railroads each had their own stations, some quite ornate. However, in many, flooding was a problem. By the 1930s, the various railroads were all located at one spot in the West End. (From the Collection of the Public Library of Cincinnati and Hamilton County.)

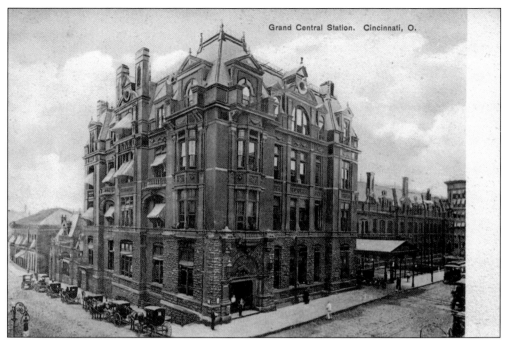

The Union Central Railroad depot, located on Third and Central, was commonly called Grand Central Station. A large Romanesque building, it had one major problem: only a few blocks from the river, with each flood, the elegant station would turn into the world's largest—and filthiest—swimming pool. (From the Collection of the Public Library of Cincinnati and Hamilton County.)

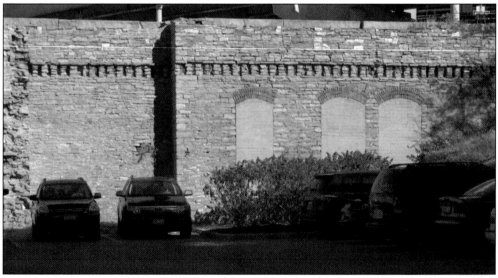

Commuters driving into town along Third Street rarely notice the tiny slab of gray stone near Central Avenue. This is all that is left of the once-proud Grand Central Station. This view, taken from the other end, shows tunnels leading from the train station under Third Street to the Grand Hotel. (Photograph by Doug Weise.)

No longer in existence today, save for one small section near Longworth Hall, this riverfront railway was raised up to alleviate disruptions due to the constant problem of floods. (From the Collection of the Public Library of Cincinnati and Hamilton County.)

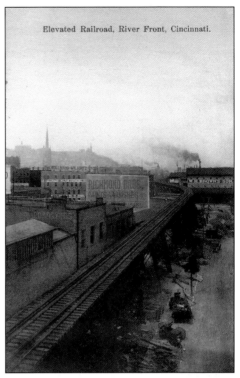

One of the architectural treasures of downtown Cincinnati is the Dixie Terminal Building on Fourth Street. Designed as a terminal for streetcars arriving and departing for Kentucky, this 1921 building features an arcade of elegant Botticino marble and reliefs of children with animals. The interior was featured in the film *Rain Man*. (From the Collection of the Public Library of Cincinnati and Hamilton County.)

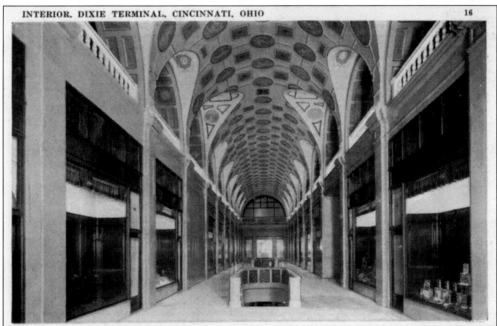

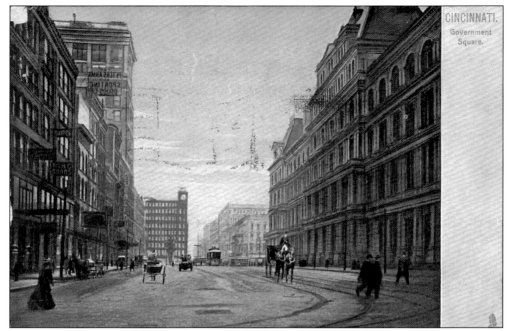

Next to Fountain Square is Government Square, which houses the offices of the federal government and is also the hub of public transportation. In 1960, presidential candidate John F. Kennedy spoke here. Despite the idyllic look of this postcard, the Square would soon become one of the busiest locations in the city. (See page 48.) (From the Collection of the Public Library of Cincinnati and Hamilton County.)

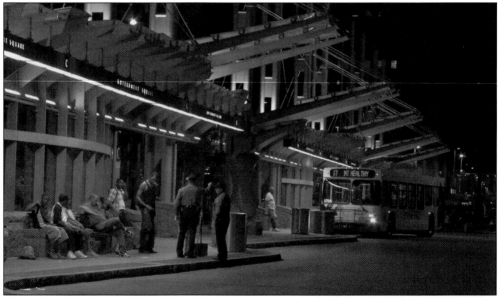

Here is a nighttime photograph of a spot that thousands of Cincinnatians see every day: Government Square. Nestled between the Federal Building and Fountain Square, Government Square serves as the downtown hub for the bus system, Metro. The buses that arrive and depart from here travel not only throughout the city and Hamilton County, but also to Warren and Clermont Counties as well. (Photograph by Doug Weise.)

Six

THE QUEEN CITY
OF THE MIDWEST

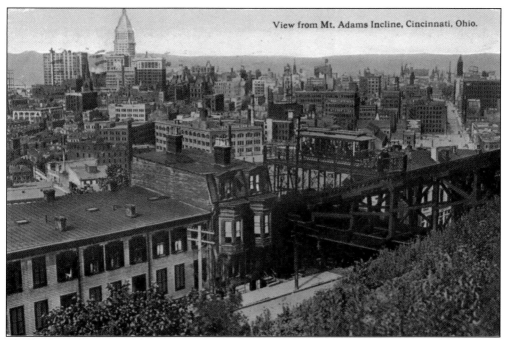

View from Mt. Adams Incline, Cincinnati, Ohio.

This spectacular view of downtown also shows the seed of its demise. Cincinnati is like a bowl with steep hills on all sides, difficult for horses. The solution was a series of inclines, as this one in Mount Adams. This facilitated movement to the hilltops and, with it, the exodus of people and business from downtown. (From the Collection of the Public Library of Cincinnati and Hamilton County.)

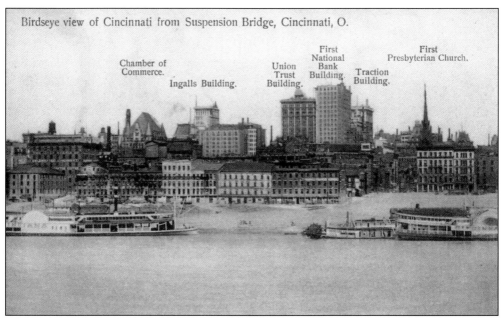

Birdseye view of Cincinnati from Suspension Bridge, Cincinnati, O.

Chamber of Commerce.

Ingalls Building.

Union Trust Building.

First National Bank Building.

Traction Building.

First Presbyterian Church.

This is an interesting shot taken sometime between 1906 and 1913 from the Roebling Suspension Bridge, showing off the skyscrapers of the emerging city. Within a few years, the skyline of the city would forever be altered by the massive Union Central Tower, and two decades later by the even larger Carew Tower. (From the Collection of the Public Library of Cincinnati and Hamilton County.)

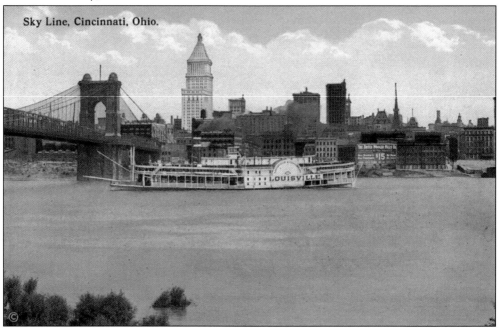

Sky Line, Cincinnati, Ohio.

From a distance, the pyramid shape of the roof of the Union Central Tower is evident. The building later featured the name of the new owners, Central Trust, proudly displayed in red neon. Now it displays the logo of PNC Bank. At Christmastime, the pillars near the top are illuminated in green and red. (From the Collection of the Public Library of Cincinnati and Hamilton County.)

Steam Boat Landing, Cincinnati,

The Ohio River gave birth to Cincinnati in 1788, but, like a child leaving its parents, the center of downtown has moved steadily away from its source. At first, the fashionable part of town was Fourth Street. As the city expanded, however, the wealthier population moved further away and eventually climbed the surrounding hills. Remaining by the river were the Irish immigrants and African Americans who performed the hard work of loading and unloading steamboats. The two groups lived close to the river in such neighborhoods as "Sausage and Rat Row," but they did not get along very well. There were conflicts, as each group felt that the other was taking their group's work. Nativist organizations, such as the "Know Nothings," exasperated this conflict. (From the Collection of the Public Library of Cincinnati and Hamilton County.)

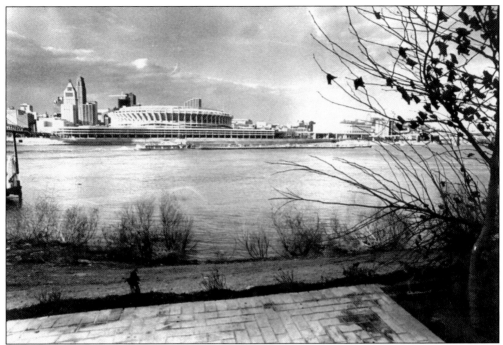

Here is a 1979 image of the home of the "Big Red Machine," Riverfront Stadium. In 1970, the Cincinnati Reds moved into Riverfront from Crosley Field, along with the Cincinnati Bengals. In 2000, the Bengals moved out to their own stadium. This facility has since been replaced by the Great American Ball Park on the same location. (Courtesy of the Kenton County Library, Covington, Kentucky.)

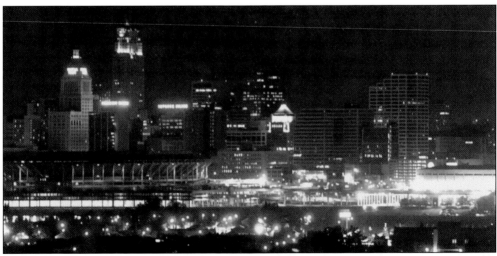

Soap opera fans may have the strange feeling that they have seen this before. The silhouette of the city skyline was part of the opening sequence of the famous CBS daytime drama *The Edge of Night*. It should come as no surprise that a soap opera would feature the skyline of the city that housed Procter & Gamble! (Courtesy of the Kenton County Library, Covington, Kentucky.)

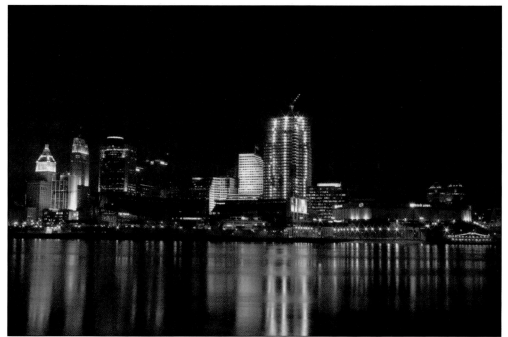

Here is a modern nighttime view of the downtown Cincinnati skyline. The city now bears little resemblance to the one depicted on *The Edge of Night*. On the right, crowned with a webbed tiara, is the new Great American Tower, which would become one of the tallest buildings in downtown Cincinnati. (Photograph by Doug Weise.)

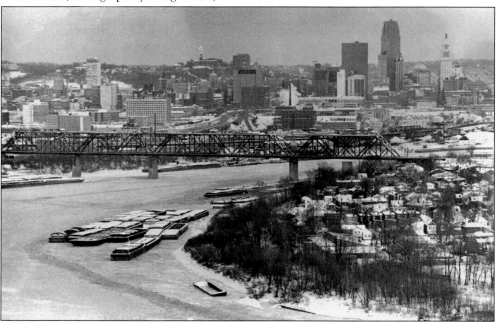

While not often photographed from this angle, one of the best vantage points for pictures of the skyline of downtown Cincinnati is from the Western Hills, particularly in autumn. This old view of the skyline, possibly from Sedamsville or Lower Price Hill, shows both the city and the bend in the river. (Courtesy of the Kenton County Library, Covington, Kentucky.)

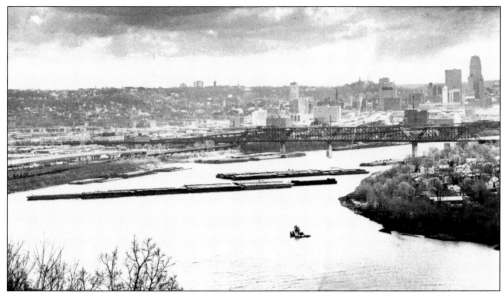

Here is a more distant view of the downtown skyline from the west. Downtown Cincinnati is on the right, while the towers of the University of Cincinnati in Clifton are just barely discernable at the top. Large barges dominate the river, the replacement for the romantic steamboats of yesterday. (Courtesy of the Kenton County Library, Covington, Kentucky.)

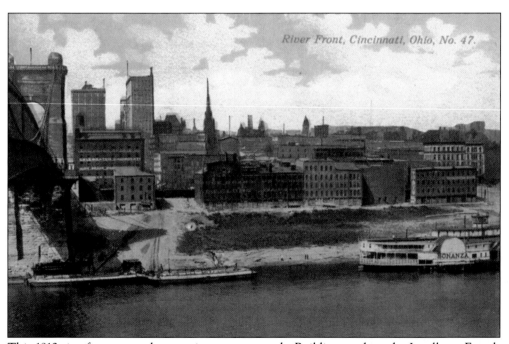

This 1912 riverfront scene shows a city at a crossroads. Buildings such as the Ingalls on Fourth Street are starting to rise to the sky but will soon be dwarfed by mammoth skyscrapers. On the right is a steamboat, but next to it are barges. On the left is the Roebling Suspension Bridge. (From the Collection of the Public Library of Cincinnati and Hamilton County.)

In the 1840s, Third Street was the center of commerce. Here were banks and the law offices of such notables as the abolitionist Salmon P. Chase, who would become Lincoln's secretary of treasury, and future president Rutherford B. Hayes. Third and Pearl Streets later became a wholesale district. (From the Collection of the Public Library of Cincinnati and Hamilton County.)

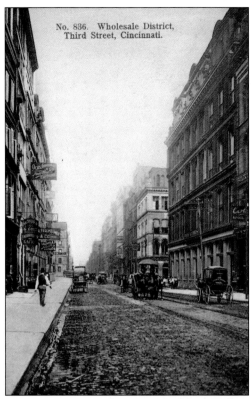

The area of Broadway leading up from Third Street was once the location of a number of inexpensive hotels. The Hotel Anderson, pictured in 1921, was located next door to the Colonial. The Dixie Hotel and a Chinese laundry occupied the bottom of the street. (From the Collection of the Public Library of Cincinnati and Hamilton County.)

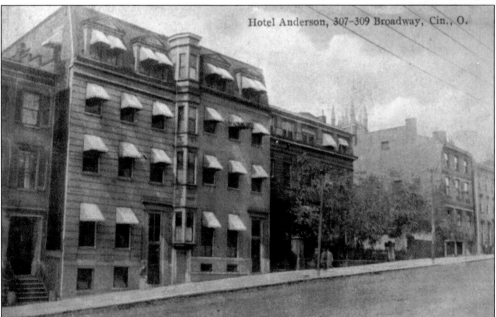

The Polk Building on Pike Street was once the site of Pugh Publishing. In 1836, Achilles Pugh published James Birney's abolitionist journal *The Philanthropist*. This did not sit well with those who made their livelihood dealing with the South. Rioters in 1836 and 1841 tried to destroy the presses. (From the Collection of the Public Library of Cincinnati and Hamilton County.)

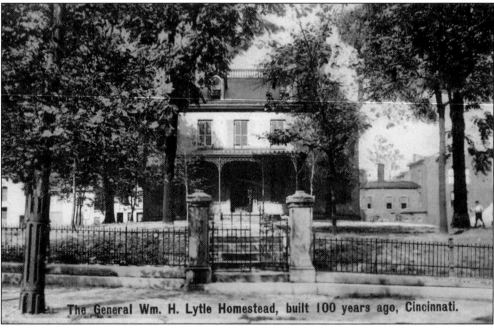

Near the Sinton mansion was the downtown home of one of Cincinnati's most famous founding families, the Lytles. It was in this house that William Haines Lytle wrote his famous poem "Antony and Cleopatra." In 1905, the city took the land, quickly razing the mansion to build Lytle Park. (From the Collection of the Public Library of Cincinnati and Hamilton County.)

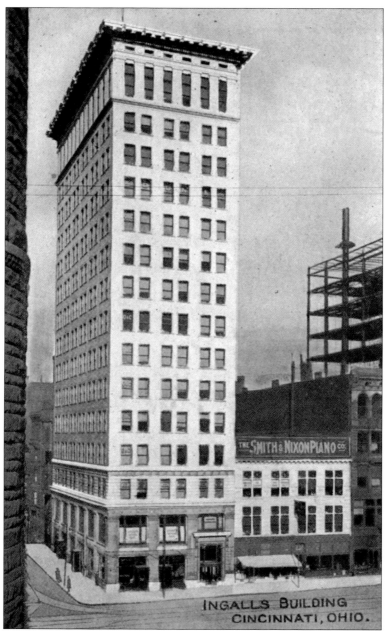

INGALLS BUILDING
CINCINNATI, OHIO.

The daring design of the Ingalls building at Fourth and Vine Streets was the brainchild of architects Elzner and Anderson in 1903. Critics were certain that the reinforced-concrete structure would collapse. One determined newspaperman camped out on the sidewalk across the street all night, waiting for the inevitable destruction. He succeeded only in missing a night's sleep—the building still stands today. For 10 years, the Ingalls Building dominated the skyline of downtown Cincinnati, just as the man who built it dominated the business world. Melville Ezra Ingalls, a railroad tycoon, helped to make Cincinnati a hub of railroad activity, forming in 1884 the conglomerate known as the Big Four. Later, he worked for the Vanderbilt organization. He was well known for his charitable work, particularly with the Cincinnati Art Museum. (From the Collection of the Public Library of Cincinnati and Hamilton County.)

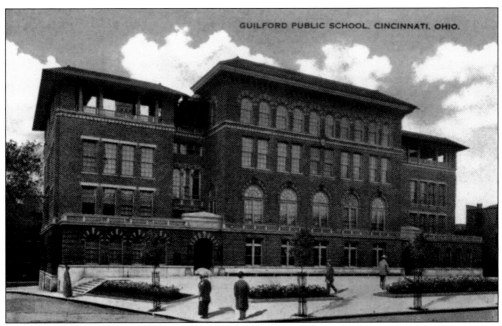

Students at Guilford School on Fourth Street did not just study history—they lived in it. This Italian Renaissance structure was built in 1914 on the site of Fort Washington. This was the location of Jane Griffin's boardinghouse, where Stephen Foster, a young worker for a steamboat company, lived from 1846 to 1850. (From the Collection of the Public Library of Cincinnati and Hamilton County.)

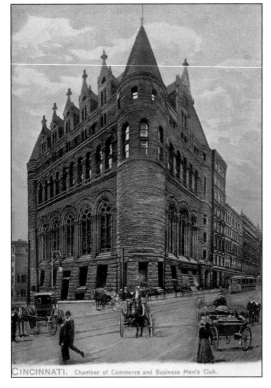

CINCINNATI. Chamber of Commerce and Business Men's Club.

Certainly one of the most important institutions in the city, the Cincinnati Chamber of Commerce traces its origins to 1839. The organization held its meetings in the Young Men's Mercantile Library. Several years later, another business group, the Merchants' Exchange, began. The groups merged and were soon housed in this magnificent Romanesque building. (From the Collection of the Public Library of Cincinnati and Hamilton County.)

Possibly the most eye-catching skyscraper in the skyline is the Union Central Building. Once the fifth-tallest skyscraper in the world, it was constructed in 1913 on the site of the burned out Chamber of Commerce building. Architect Cass Gilbert added a pyramid roof topped with a bronze replica of the magnificent tomb of King Mausolus. (From the Collection of the Public Library of Cincinnati and Hamilton County.)

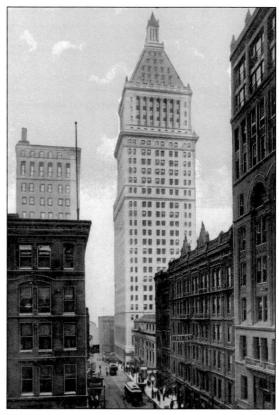

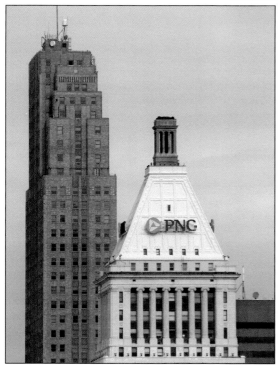

Here is a close-up view of the ornamental building on top of the Union Central (now PNC) Tower. The original tomb of King Mausolus in Turkey (from which we get the word mausoleum) was one of the wonders of the ancient world. Like a church steeple, the structure moves the eyes above the city—beyond the work of man—and up to heaven. (Photograph by Doug Weise.)

FIRST NATIONAL BANK BUILDING,
S. E. Cor. 4th and Walnut Sts. Cincinnati, O.

Here is a little bit of Chicago right in the Queen City. The Clopay Building (a combination of the words *clothing* and *paper*) was built in 1904. The Chicago design emphasizes function over ornamentation. The bottom stories have some design, but the lines upward are straight and severe. Not surprisingly, the architect, Daniel Burnham, was from Chicago. (From the Collection of the Public Library of Cincinnati and Hamilton County.)

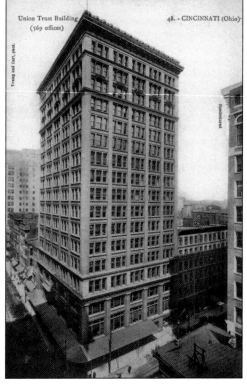

The 20th century began with a bang for the Cincinnati skyline with the first skyscraper in the city. On New Year's Day in 1901, the Union Trust Building on Fourth Street was dedicated. It was the product of Jacob Schmidlapp, designed by Daniel Burnham. The Bartlett Company bought the building in 1985. (From the Collection of the Public Library of Cincinnati and Hamilton County.)

Keyboard manufacturers Baldwin and Wurlitzer both
began in downtown Cincinnati. In 1853, Franz Rudolph
Wurlitzer began importing instruments. Thirty years later,
they began to make their own, including a renowned line
of harps. The most famous of the company's products is
the mammoth Mighty Wurlitzer used in churches and
large theaters. (From the Collection of the Public Library
of Cincinnati and Hamilton County.)

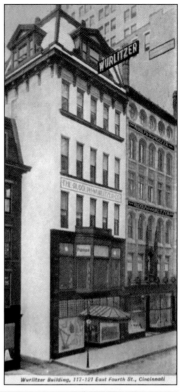

Wurlitzer Building, 117-121 East Fourth St., Cincinnati

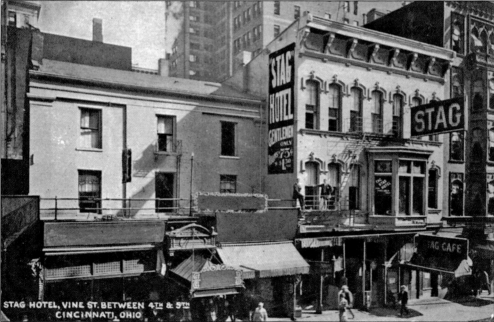

STAG HOTEL, VINE ST. BETWEEN 4TH & 5TH
CINCINNATI, OHIO

Part of a complex including a restaurant and a tavern as well as a hotel, Joe Coyle's Stag was a
popular destination for business travelers on a budget. The hotel, "For Gentlemen Only," promised
that it was "Convenient, Clean and Comfortable." Rooms were either 75¢ or $1 a day. (From the
Collection of the Public Library of Cincinnati and Hamilton County.)

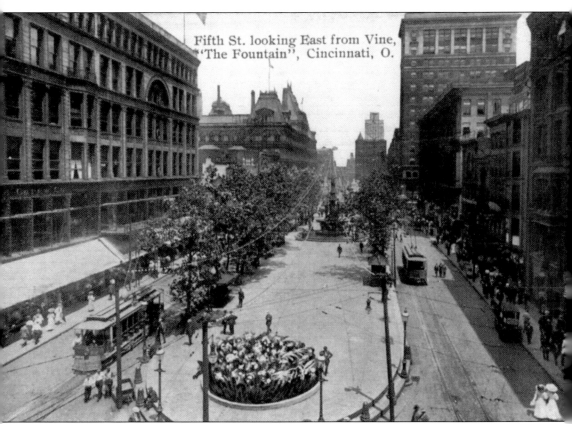

Fifth St. looking East from Vine, "The Fountain", Cincinnati, O.

Fountain Square is more than just a fountain. Dedicated on October 6, 1871, the fountain is essentially the heart and soul of Cincinnati. The peaceful esplanade of Fountain Square was a great improvement over the dilapidated and disgusting open-air butcher market that had been there since 1827. When the city acquired the property on February 4, 1870, it lost no time in removing the eyesore. The butcher market was demolished in just one night, before any serious legal action could be taken to stop them. Architect William Tinsley originally designed the Square as an oval in the center of Fifth Street. The heavy traffic made access to the park difficult and even dangerous. (From the Collection of the Public Library of Cincinnati and Hamilton County.)

The benefits of water are depicted in the fountain's various figures. However, the symbol of Cincinnati was not commissioned for that purpose. August von Kreling cast *The Genius of Water* in Nuremberg in 1840. It sat forgotten in storage in Munich for two decades before being purchased by Henry Probasco to memorialize his former business partner and brother-in-law Tyler Davidson. (Library of Congress, LC-USF33-001186-M3.)

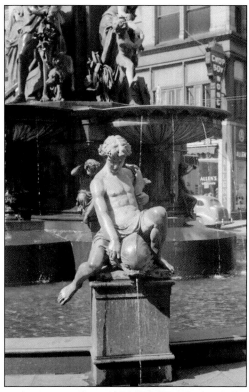

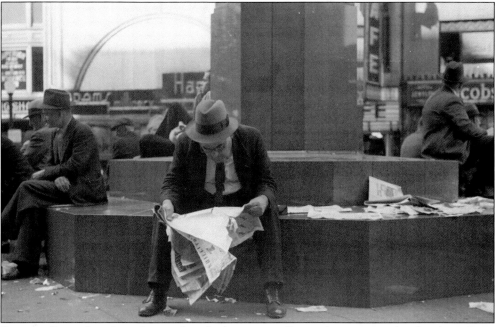

Fountain Square has always been a place for downtown office workers to enjoy their lunch outdoors, to sit and talk with others, or just stop to read a newspaper. This photograph from the 1930s shows a man doing just that, perhaps looking for a job, or an immigrant reading news from home. Either way, it looks like bad news. (Library of Congress LC-USF33-T01-001218-M1.)

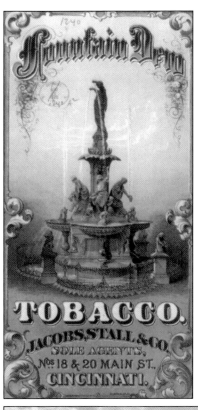

Cincinnatians were certainly proud of their new fountain and the image of a growing city that it projected to the world. Jacob, Stalls & Co. on Main Street used the fountain to repackage Mountain Dew tobacco. Although the name would have little to do with mountains or water, the image would certainly catch the eye of a potential Cincinnati customer. (Library of Congress LC-USZ62-51732.)

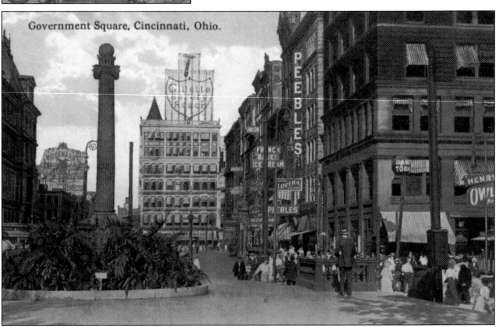

Near the center of this view of Government Square is the vertical sign for the Peebles Grocery Store. This small local chain, begun by Joseph Peebles, also had a large store in Walnut Hills. It is from this store that the name of the major intersection Peebles Corner comes. (From the Collection of the Public Library of Cincinnati and Hamilton County.)

Designed by Chicago's Walter W. Ahlschlager, the 48-story Carew Tower remains the most prominent building in the Cincinnati skyline. A stunning example of Art Deco architecture, the 574-foot tall skyscraper was built in 1930 in little more than a year by Starrett Brothers & Eken, the same company that produced New York's Empire State Building. (Courtesy of the Kenton County Library, Covington, Kentucky.)

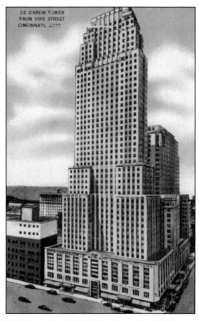

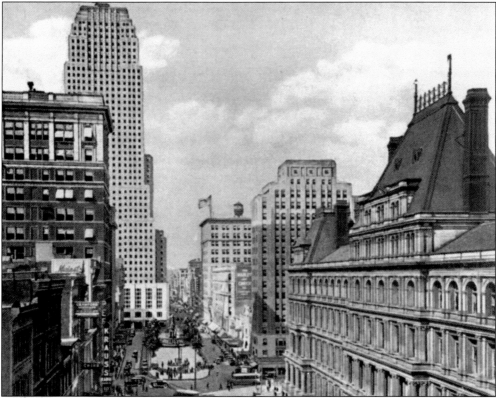

The "wedding cake" design of the Art Deco skyscraper follows the spirit of a 1916 New York law preventing large buildings from blocking too much sunlight. It serves its purpose well, keeping Fountain Square from being in permanent shadow. (Courtesy of the Kenton County Library, Covington, Kentucky.)

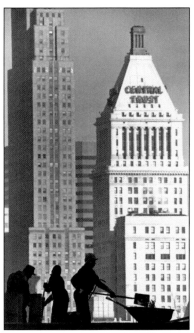

Here is a rendering of downtown Cincinnati as a city of progress and on the move. The message of a city growing and thriving is clear. The actual skyline of the downtown area has changed drastically since this picture was made. (Courtesy of the Kenton County Library, Covington, Kentucky.)

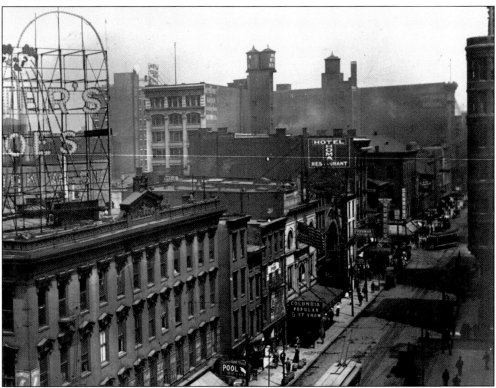

Here is a turn-of-the-century view of downtown Cincinnati, definitely a city growing quickly. To the English writer Sir James Macauley, the city demonstrated a "staid, compact almost venerable look." The streetcar is running on electricity rather than horsepower, an innovation that began in the 1880s. (Courtesy of the Kenton County Library, Covington, Kentucky.)

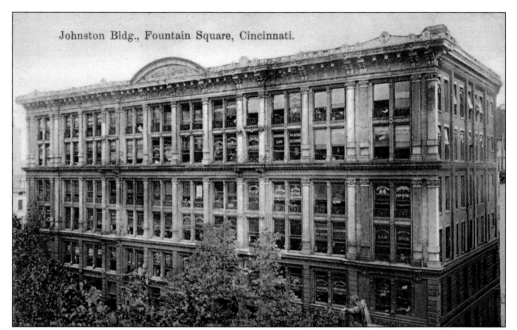

Johnston Bldg., Fountain Square, Cincinnati.

Located right on the esplanade of Fountain Square, the Johnston Building was one of the more prestigious business addresses in downtown Cincinnati. (From the Collection of the Public Library of Cincinnati and Hamilton County.)

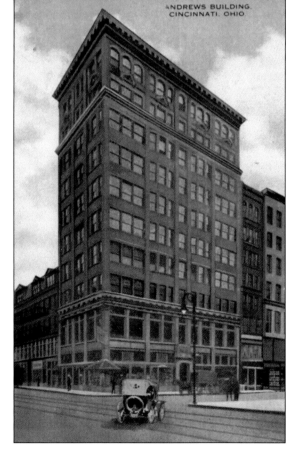

ANDREWS BUILDING.
CINCINNATI. OHIO.

This building at the corner of Fifth and Race Streets was sold in 1929 for the outrageous price of $1 million. Mary Andrews Kilgour sold the property to Thomas Emery and Sons, who already owned all of the other property on the entire block—including the city's tallest skyscraper, the Carew Tower. (From the Collection of the Public Library of Cincinnati and Hamilton County.)

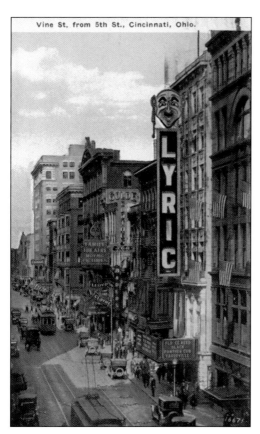

Vine St. from 5th St., Cincinnati, Ohio.

It was 1925, the start of a new era for Cincinnati. After "Boss" Cox died, the reins of power fell to Rudolph Hynicka. Rudolph spent time in New York and tried to run Cincinnati by long distance. When "the cat was away," the mice formed the Charterite Party and, in 1924, removed city government from the old machine. (From the Collection of the Public Library of Cincinnati and Hamilton County.)

The newspaper *Times Star* was the blending of the 1840 *Spirit of the Times* along with the hard-hitting *Star* of 1872. David Sinton and his son-in-law Charles Taft purchased and merged the two papers in 1880. Four years later, the paper pioneered the use of telegraphs to report national news quickly. (From the Collection of the Public Library of Cincinnati and Hamilton County.)

Building of CINCINNATI TIMES STAR CO. Electrical Week, Nov. 29

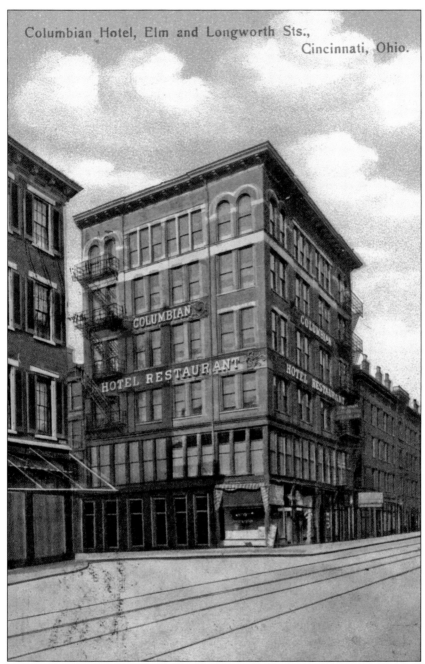

Columbian Hotel, Elm and Longworth Sts., Cincinnati, Ohio.

A terrible tragedy was narrowly averted at this cheap hotel on Elm Street. Apparently, the owner had a problem with deadbeat guests sneaking out in the middle of the night to avoid paying their bills. To stop this thievery, he placed chicken wire on exits to keep his valued customers from wandering away. The fire inspector made his usual rounds and declared that the Columbia was one of the worst firetraps in the country. Naturally, he ordered the owner to immediately take down the chicken wire or face a severe fine. A week later, a fire in the elevator shaft spread quickly throughout the building. Luckily, all residents were able to escape through the now-clear exits. (From the Collection of the Public Library of Cincinnati and Hamilton County.)

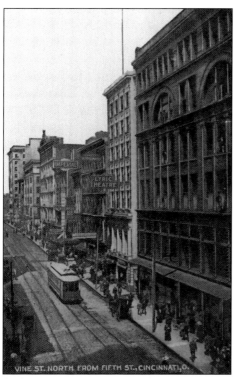

Looking north from Fountain Square, this early shot shows both the Lyric and Imperial Theaters. American history was almost affected by entertainment at this spot. In 1856, the Democrats were trying to nominate Buchanan for president. However, just outside of their meeting was Madame Tournaire's French Circus. Delegates would sneak away to watch the acts. (From the Collection of the Public Library of Cincinnati and Hamilton County.)

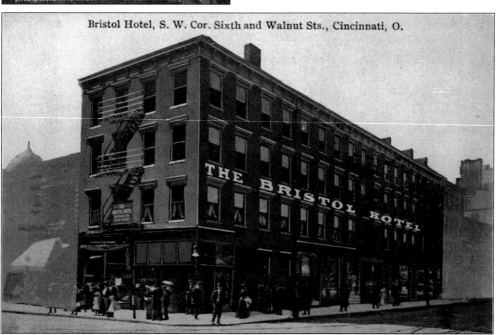

With a history stretching back to pioneer days, the Bristol at Sixth and Walnut Streets was originally known as the Crawford House. While not luxurious, the Bristol had its share of prominent guests. Among these was Mark Twain (Samuel Clemens), then a steamboat pilot. Circus owners, including P.T. Barnum, would meet here yearly. (From the Collection of the Public Library of Cincinnati and Hamilton County.)

One of the major buildings in downtown actually has cows on it. The Gwynne Building at Sixth and Main Streets was completed in 1913. The bovine decorations were probably the idea of New York architect Ernest Flagg, cousin of Alice G. Vanderbilt. The building once housed Cincinnati's largest business, the Procter & Gamble Company. (From the Collection of the Public Library of Cincinnati and Hamilton County.)

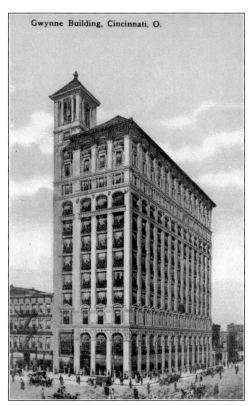

Gwynne Building, Cincinnati, O.

Moo! Here is a close-up of one of the cow statues on the side of the Gwynne Building. While walking through downtown Cincinnati, it is often a good idea to look above the modern storefronts to see the history and unusual surprises that may be, like this herd of stone cows, hidden in plain sight. (Photograph by Doug Weise.)

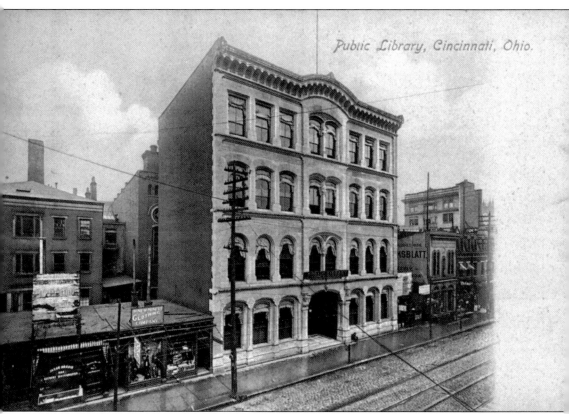

One downtown feature that Cincinnatians are justly proud of is the Cincinnati and Hamilton County Public Library. Begun in 1802 as a subscription library, it has grown to become the ninth-largest library system in the nation. In the late 1800s, this building at 629 Vine Street could not hold all of the books. A curious feature of the early Vine Street location of the Public Library was a controversy surrounding the three decorative heads that graced the entrance. The likenesses of Shakespeare and Franklin were obvious. However, the third was either Milton or the 18th-century German poet and philosopher Friedrich Schiller. Arguments raged for years between adherents of the two factions. The library (without the decorative heads) is now located two blocks north of the old location. (From the Collection of the Public Library of Cincinnati and Hamilton County.)

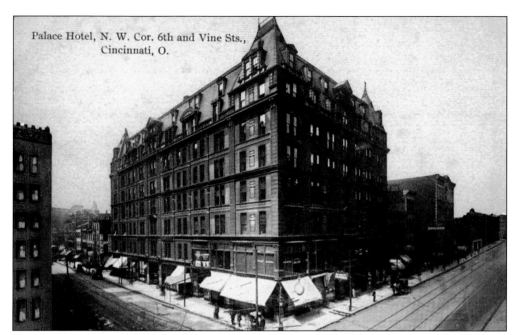

Palace Hotel, N. W. Cor. 6th and Vine Sts., Cincinnati, O.

Now the Cincinnatian Hotel, the Palace opened in 1882 next to the Atlantic Gardens. The Gardens, a popular venue for entertainment, once staged a prizefight featuring the beginning fighter John L. Sullivan. The police insisted that the combatants wear gloves, much to the dissatisfaction of the fans. (From the Collection of the Public Library of Cincinnati and Hamilton County.)

This old institution is now an apartment complex. As downtown Cincinnati has undergone a renovation in recent years, the Metropole has found itself now in the center of an arts district. Right next door is the Contemporary Arts Center. Across the street is the Aronoff Center, a venue for Broadway plays and even the Cincinnati Ballet. (From the Collection of the Public Library of Cincinnati and Hamilton County.)

HOTEL METROPOLE
CINCINNATI. O.

Here is a 1910 view of Race Street at Seventh Street, where Shillito's Department Store chose to relocate. Some worried that this spot was too far away from the center of town to be competitive. After more than a century, the store (now Macy's) moved down to Fifth Street, across the street from Saks Fifth Avenue. (From the Collection of the Public Library of Cincinnati and Hamilton County.)

Hidden away in the northeast corner of downtown Cincinnati on Broadway is another Samuel Hannaford masterpiece. Designed by Eldridge Hannaford, this 1933 Art Deco skyscraper was once occupied by the *Post-Times Star* newspaper. Designed in an overwhelming Art Deco style, the top of the building is dominated by giant allegorical figures. There is modernist ornamentation over seemingly every inch of the building's facade. (Photograph by Jordan Rolfes.)

John Wright and Timothy Walker started the Cincinnati Law School on Ninth Street in 1833. Among its prominent graduates was William Howard Taft. One of the instructors here was the celebrated Civil War general Manning Force. (From the Collection of the Public Library of Cincinnati and Hamilton County.)

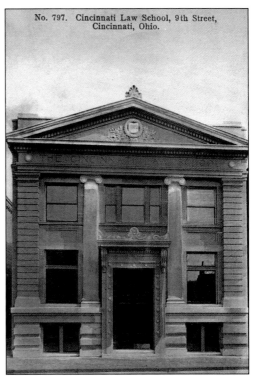

No. 797. Cincinnati Law School, 9th Street, Cincinnati, Ohio.

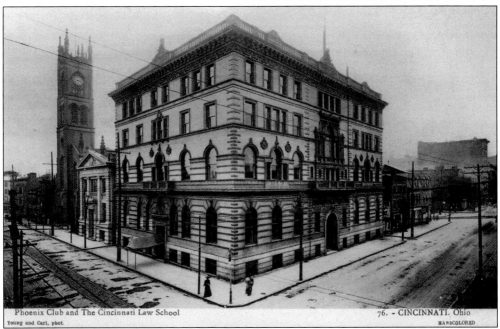

Phoenix Club and The Cincinnati Law School
Young and Carl, phot.
76. - CINCINNATI. Ohio
HANDCOLORED

The Phoenix Club began in 1893 as a Jewish Businessmen's Club and closed in 1983. But, like the mythical bird it is named for, it rose from the ashes. While it was closed, the Tiffany stained-glass windows were stolen. During the trial, the windows mysteriously reappeared—in the courthouse hallway. The charges were dismissed. (From the Collection of the Public Library of Cincinnati and Hamilton County.)

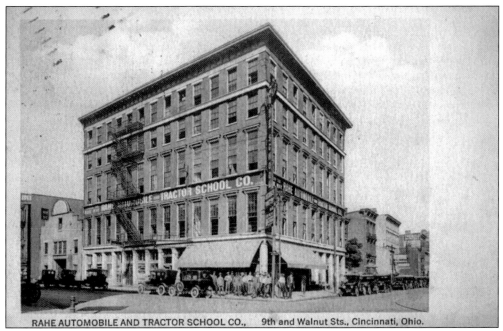

RAHE AUTOMOBILE AND TRACTOR SCHOOL CO., 9th and Walnut Sts., Cincinnati, Ohio.

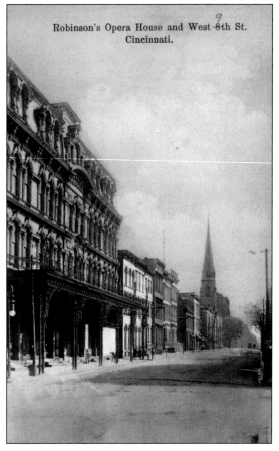

Robinson's Opera House and West 8th St. Cincinnati.

A national firm based out of Kansas City, Henry J. Rahe's company operated schools for mechanics. After establishing a reputation by training mechanics for the war in 1918, the company boomed afterwards. Their advertisements told young men that there would be a need for skilled mechanics once the shortages due to the war were over. (From the Collection of the Public Library of Cincinnati and Hamilton County.)

The adage of yelling "Fire!" in a crowded theater was put to the test in Robinson Opera House, with devastating results. In 1876, a boy shouted the alarm as a prank. A total of 10 people died, and 100 were injured. John Robinson was a circus man who kept his animals in the basement in winter. (From the Collection of the Public Library of Cincinnati and Hamilton County.)

Seven

THE SOUL OF DOWNTOWN CINCINNATI

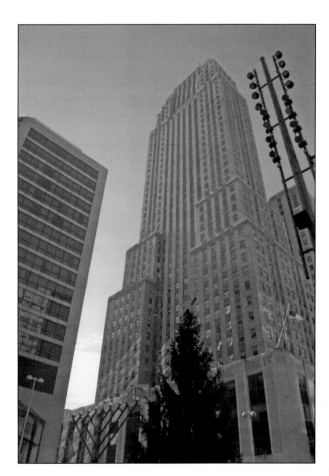

A menorah is placed on the Square to commemorate the Jewish festival of Chanukah. Here is the menorah; behind it, the massive Christmas tree, and behind that the ascending Carew Tower. Above the busy streets and concerns of the everyday world, all eyes are lifted to heaven. (Photograph by Jordan Rolfes.)

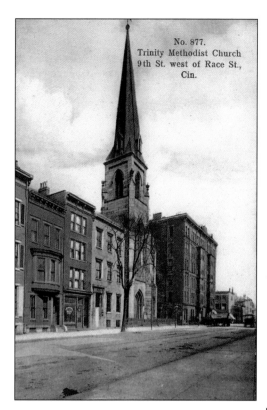

No. 877.
Trinity Methodist Church
9th St. west of Race St.,
Cin.

Methodists have a long history in downtown Cincinnati, arriving on horseback in 1793 with Rev. John Kobler. Ten years later, John Collins organized a small congregation, which flourished. The Trinity Methodist Church was located on Ninth Street, but today the building is no longer a Methodist house of worship. (From the Collection of the Public Library of Cincinnati and Hamilton County.)

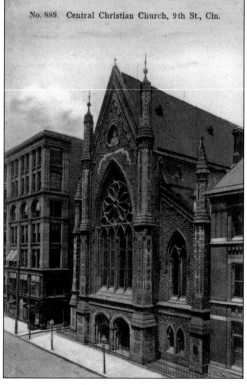

No. 889. Central Christian Church, 9th St., Cin.

The Baptists established their initial church in Cincinnati in 1813 on Front Street. Congregations grew in Cincinnati during the early 19th century under the tutelage of a Kentucky preacher named Jeremiah Vardeman. In 1828, a group of 118 members left to form the Central Christian Church on Ninth Street, following the "Second Great Awakening" teachings of Alexander Campbell. (From the Collection of the Public Library of Cincinnati and Hamilton County.)

The Episcopal Christ Church Cathedral is located on Fourth Street, the financial heart of downtown. Included among the many parishioners was the famed physician Daniel Drake. It was Drake who, in 1817, originally had services in his home. The church was built 18 years later. (From the Collection of the Public Library of Cincinnati and Hamilton County.)

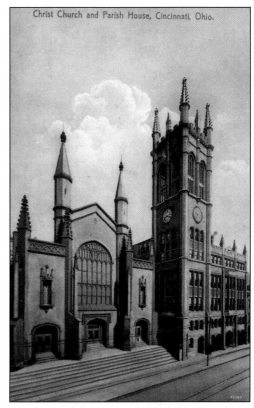

Christ Church and Parish House, Cincinnati, Ohio.

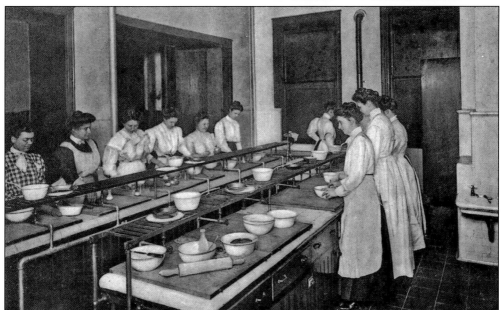

Christ Church looked after not only the spiritual needs of its members, but practical needs as well. A number of activities and classes were offered to help the congregation meet the demands of everyday life. In this 1912 photograph, we see young ladies learning the culinary arts. (From the Collection of the Public Library of Cincinnati and Hamilton County.)

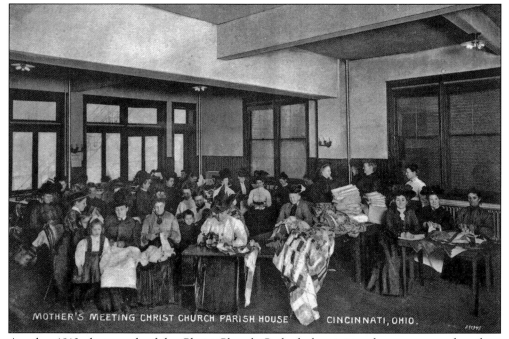

MOTHER'S MEETING CHRIST CHURCH PARISH HOUSE CINCINNATI, OHIO.

Another 1912 photograph of the Christ Church Cathedral activities shows a group of mothers spending a happy afternoon in conversation and getting a little sewing done at the same time. (From the Collection of the Public Library of Cincinnati and Hamilton County.)

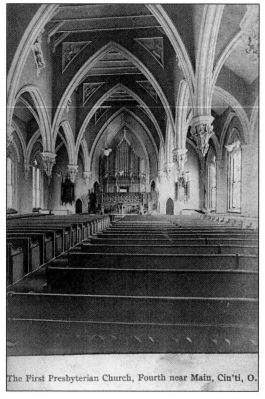

The First Presbyterian Church, Fourth near Main, Cin'ti, O.

The First Presbyterian Church was located for many years on Fourth Street near Main Street. Israel Ludlow formed the congregation in 1790. Declining membership in the downtown area forced other churches to combine into one church on Eighth Street. In 1934, First Presbyterian closed its doors and merged to form the Covenant-First. (From the Collection of the Public Library of Cincinnati and Hamilton County.)

One of the most impressive downtown churches is the Covenant First Presbyterian Church on Elm Street facing Piatt Park. The church was originally the Second Presbyterian. As the years passed, many of the parishioners moved to the suburbs, forcing the combination of churches in the downtown area. The Gothic stone building was built in 1875. (From the Collection of the Public Library of Cincinnati and Hamilton County.)

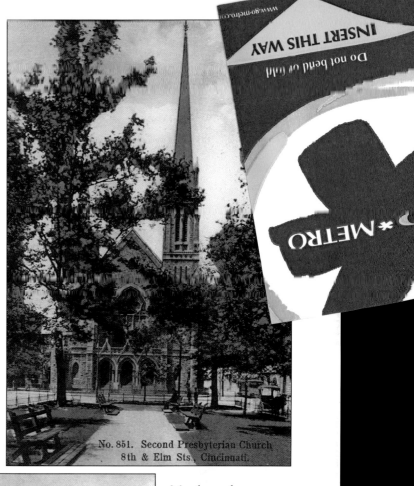

No. 851. Second Presbyterian Church 8th & Elm Sts., Cincinnati.

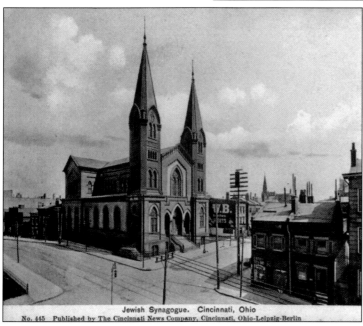

Jewish Synagogue. Cincinnati, Ohio
No. 445 Published by The Cincinnati News Company, Cincinnati, Ohio-Leipzig-Berlin

Members of a synagogue on Broadway purchased land near Mound Street in 1865. Four years later, the temple was opened under the leadership of Dr. Max Lilienthal. Dr. Lilienthal had resigned in 1868 to head a synagogue in New York but was persuaded to remain in Cincinnati. The temple later relocated to Avondale. (From the Collection of the Public Library of Cincinnati and Hamilton County.)

107

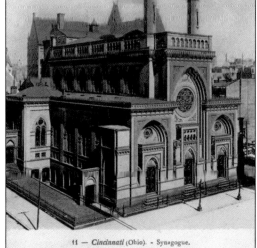

11 — *Cincinnati* (Ohio). - Synagogue.

Revival design features two minarets in front. (From the Collection of the Public Library of Cincinnati and Hamilton County.)

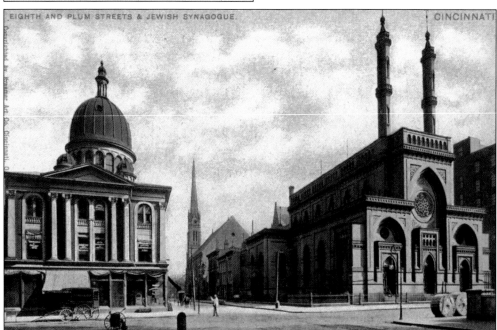

EIGHTH AND PLUM STREETS & JEWISH SYNAGOGUE. CINCINNATI

Three great religious buildings once flanked Plum Street near City Hall. On one side is the Catholic cathedral St. Peter in Chains. Across the street is the Isaac Wise Temple. Gone now is the St. Paul Episcopal Cathedral. Built in 1852 and demolished in 1937, it was the church of many prominent Cincinnatians, including Salmon P. Chase. (From the Collection of the Public Library of Cincinnati and Hamilton County.)

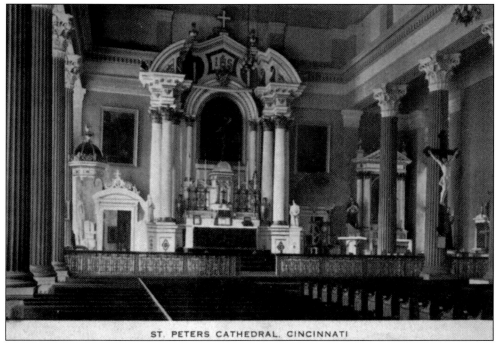

ST. PETERS CATHEDRAL, CINCINNATI

St. Peter in Chains cathedral on Elm Street, named after a painting by Murillo, was completed in 1842. Corinthian columns support the classical exterior; the interior is Byzantine. The cathedral fell into such disrepair that St. Monica's church in Clifton temporarily served as the archdiocese cathedral. St. Peter's was finally restored in the 1950s. (From the Collection of the Public Library of Cincinnati and Hamilton County.)

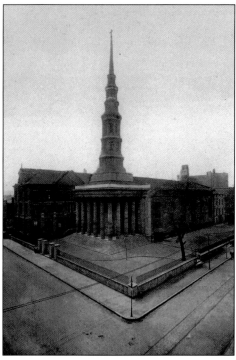

This location was once the scene of a riot. On Christmas Day in 1853, Archbishop Purcell hosted the Apostolic Nuncio Cardinal Bedini in the rectory by the Cathedral. An anti-Catholic mob attacked the residence but was stopped by the police. One man died, and many were injured in the confrontation. (From the Collection of the Public Library of Cincinnati and Hamilton County.)

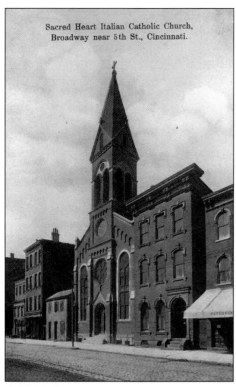

Sacred Heart Italian Catholic Church, Broadway near 5th St., Cincinnati.

Sacred Heart Catholic Church began services in August of 1893. Located across from the Commercial Square, Sacred Heart served Cincinnati's small population of Italians. Cardinal Satolli, the Papal Delegate to the United States, dedicated it. The church has since moved to Camp Washington. (From the Collection of the Public Library of Cincinnati and Hamilton County.)

Sisters of Notre Dame Convent, 6th near Broadway, Cincinnati.

Located on Sixth Street near Broadway, this was one of the first foundations of the Sisters of Notre Dame de Namur in the United States. The order, dedicated to educating poor people, was founded in Amiens in 1803. The Sisters came to Cincinnati at the request of Archbishop Purcell. (From the Collection of the Public Library of Cincinnati and Hamilton County.)

Churches generally do not move, but the first Catholic Church in Cincinnati did exactly that. Due to anti-Catholic sentiment, the first church was built at Liberty and Vine Streets. In 1825, the church frame was put on wheels and defiantly rolled into downtown to become St. Xavier on Sycamore. The original location is now St. Francis Church in Over-the-Rhine. (From the Collection of the Public Library of Cincinnati and Hamilton County.)

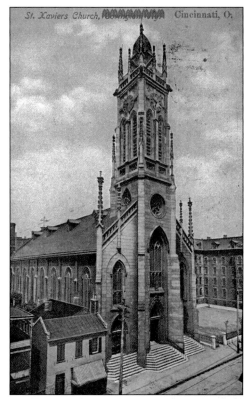

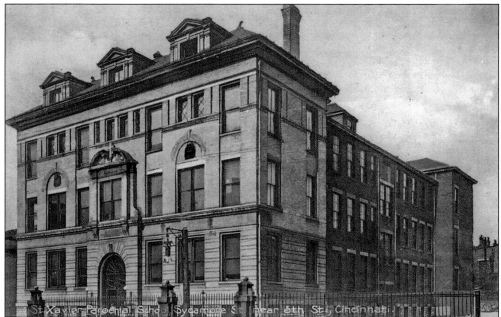

St. Xavier High School had its start a block south of the St. Xavier church. One of the pastors of the St. Xavier church and school was Fr. Francis Finn. He founded the St. Xavier Commercial School for Girls and wrote a number of boys' adventure books, including *Tom Playfair* and *Bobby in Movieland*. (From the Collection of the Public Library of Cincinnati and Hamilton County.)

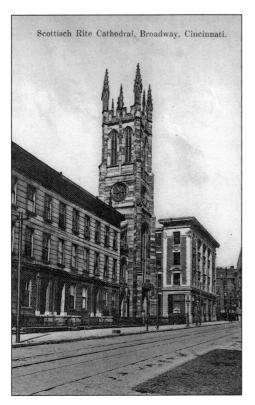

Scottisch Rite Cathedral, Broadway, Cincinnati.

This imposing Romanesque structure was replaced by a more modern and less conspicuous building. Next to the Taft Theater on Fifth Street at Sycamore is a large building housing the city's Masonic activities. The limestone exterior of the new building is noted for its simplicity and subtle ornamentation. (From the Collection of the Public Library of Cincinnati and Hamilton County.)

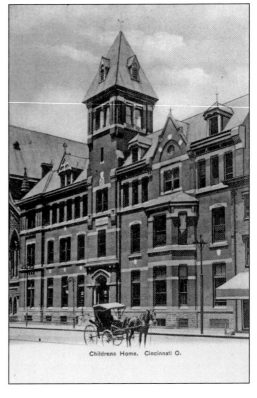

Childrens Home. Cincinnati O.

This institution on Plum Street was the product of one man's determination to help young people and ignore red tape in doing so. In 1864, due to the war, many children were in need. Refusing to separate anyone by social standing or race, Quaker Murray Shipley used his own money and opened this home. (From the Collection of the Public Library of Cincinnati and Hamilton County.)

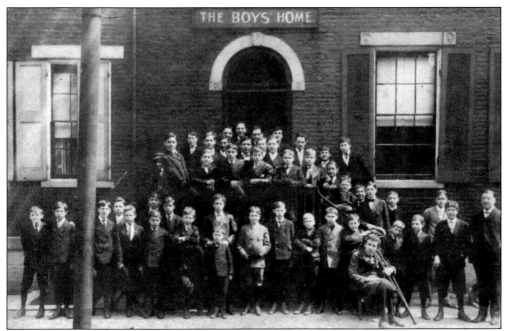

In 1885, Fr. John Poland tried to provide a home for one boy. The number jumped to six, and grew steadily after that. The first such home was on Seventh Street near Main. They quickly outgrew those quarters and moved to Fifth Street. In 1915, it moved to Pioneer Street and connected with the Fenwick Club. (From the Collection of the Public Library of Cincinnati and Hamilton County.)

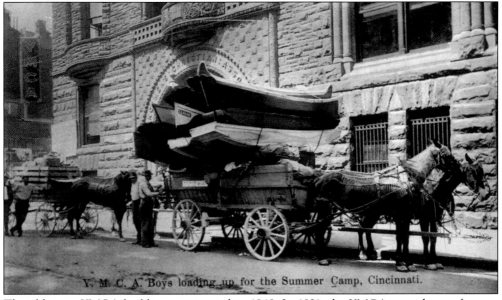

The old stone YMCA building was erected in 1848. In 1921, the YMCA moved away, leaving the property to become the Schubert Theater. The Schubert was a fixture in downtown for five decades, before being demolished in 1976. The YMCA crossed the "Rhine" and is located on the north side of Central Parkway. (From the Collection of the Public Library of Cincinnati and Hamilton County.)

The Anna Louise Inn (misspelled on the postcard) is named after a daughter of the founders, Anna and Charles Taft. Located across the street from the Taft Museum of Art, the institution assists women with inexpensive lodging. The building was constructed in 1909 and then enlarged in 1920. It is operated by the Union Bethel. (From the Collection of the Public Library of Cincinnati and Hamilton County.)

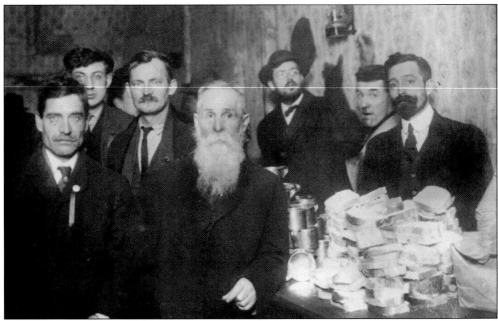

Throughout the years, Cincinnati has hosted countless conventions. Presidents such as James Buchanan have received their nominations from conventions held in the downtown area. One of the most unusual conventions—for hobos—was held in 1912. In that year, downtown hosted those who have no home. (Library of Congress, LC-DIG-ggbain-10108.)

Eight

WATER, WIND, FIRE, ICE—AND MAN

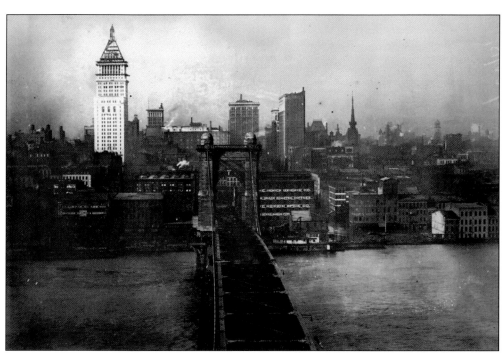

The most common natural disasters to strike downtown Cincinnati are floods. Over the years, the river that gave birth to the Queen City would rise up in anger, stopping vital river traffic and sweeping away old buildings near the riverfront. The first major flood was in 1847, the most recent in 1997. In 1907, the river flooded in January, then again in spring. (Library of Congress, LC-DIG-ggbain-12028.)

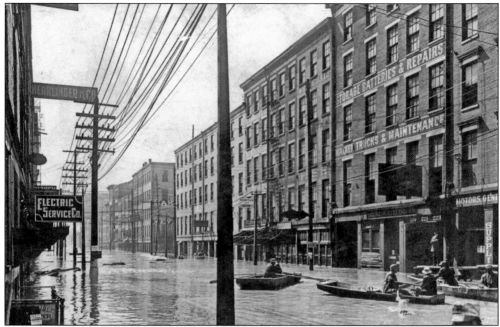

Rowboats were the only way to travel in a flood. Children would create makeshift boats out of timbers. In 1884, two women, Mollie Baldwin and Nellie Clark, convinced some men to take them for a boat ride. Their rowboat struck a lamppost, knocking the women into the water. They hung on to each other, sunk, and drowned. (From the Collection of the Public Library of Cincinnati and Hamilton County.)

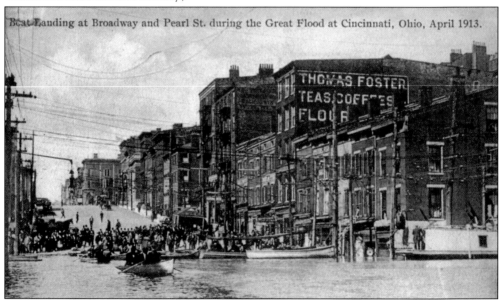

The 1913 flood has been crowned as Ohio's worst weather disaster, affecting nearly every city in the state. In Cincinnati, the river rose an unbelievable 21 feet in just one day. Carpenters in City Hall's workrooms labored night and day constructing relief boats. Soon, all rowboats were pressed into service, with or without the owners' consent. (From the Collection of the Public Library of Cincinnati and Hamilton County.)

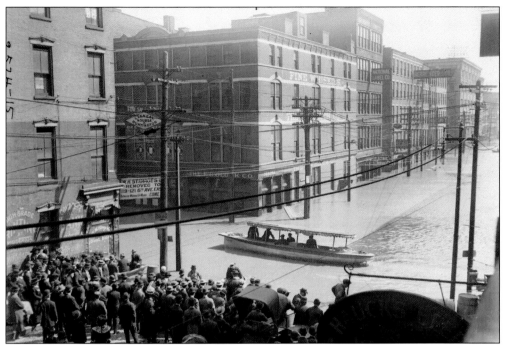

Sometimes, downtown Cincinnati would resemble Venice. Massive floods in 1883 and 1884 are thought to be contributing factors in the Courthouse Riot. In 1910, a series of wicket dams throughout the river was begun. These were completed in 1929 but were of little help in 1937. Today, two major dams, the Markland and the Meldahl, keep the river under control. (Library of Congress LC-DIG-ggbain-12015.)

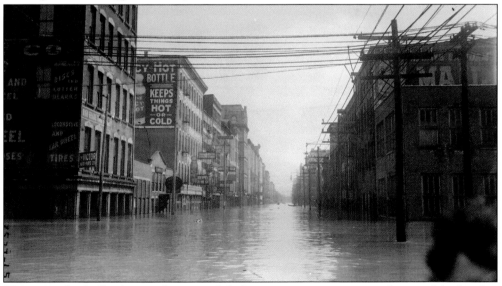

The approach of a flood meant frantic work for businessmen operating near the river. Merchandise stored in warehouses, such as these along Elm Street, had to be moved. One curious result of the 1884 flood was that a number of homes on higher ground suddenly found their parlors graced with a piano, as friends and relatives needed safe places to store their instruments. (Library of Congress LC-DIG-ggbain-12029.)

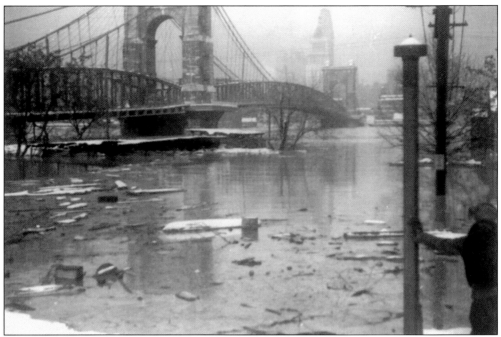

On January 26, 1937, the Ohio River at Cincinnati crested at an unbelievable 80 feet, bringing water to areas of the city that had never experienced flooding in the past. Heavy snow and rain created havoc from Pittsburgh to Cairo, Illinois. Note the debris floating in the water. (Courtesy of the Kenton County Library, Covington, Kentucky.)

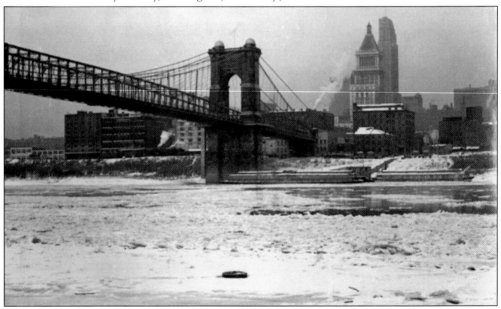

Floods are not the only danger posed to downtown Cincinnati by the volatile Ohio River. Sometimes, the river has frozen, posing a great threat to steamboats docked at the public landing. Possibly the worst such case was in January 1918, when the ice crushed the hulls of eight steamboats, including the beloved Coney Island excursion boat. (Courtesy of the Kenton County Library, Covington, Kentucky.)

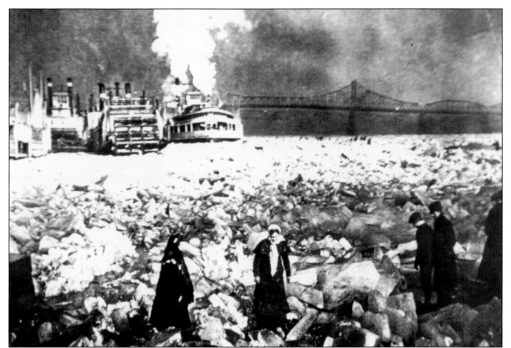

Whenever the Ohio River freezes completely, there are always a few people, not laboring under the excessive weight of intelligence or common sense, who walk out onto the ice. Some people take this foolishness to the extreme of walking all the way across the river to Kentucky! (Courtesy of the Kenton County Library, Covington, Kentucky.)

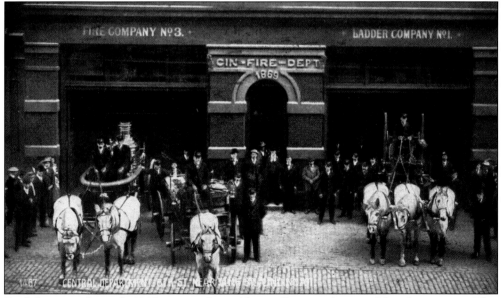

Firefighting in the early 1800s was performed by small, privately owned fire departments. This haphazard method would often result in confusion at fire scenes and sometimes ended in brawls. On April 1, 1853, Cincinnati ended this by establishing the first municipal fire department. Cincinnati was the first to use the innovation of steam engines. (From the Collection of the Public Library of Cincinnati and Hamilton County.)

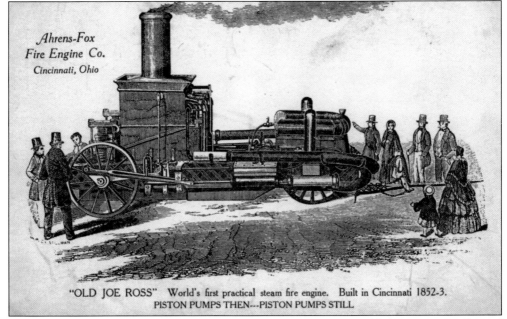

"OLD JOE ROSS" World's first practical steam fire engine. Built in Cincinnati 1852-3.
PISTON PUMPS THEN---PISTON PUMPS STILL

The very first steam fire engine in the nation, the "Uncle Joe" could shoot 1,000 gallons of water a minute towards a blaze. Manufactured by the Ahrens-Fox Company in Cincinnati, the monstrous machine weighed over 12 tons. While it was partially self-propelled, horses were still required to pull the machine quickly to the fire. (From the Collection of the Public Library of Cincinnati and Hamilton County.)

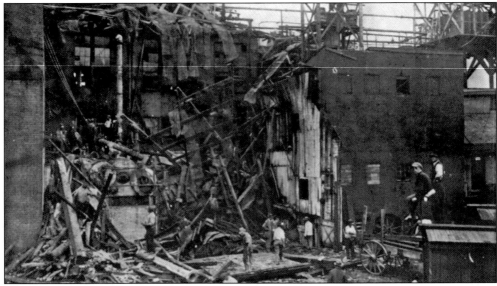

On July 7, 1915, a freak summer storm spawned high winds that struck the crowded downtown area. There was no conclusive evidence of an actual tornado in this storm, but the damage was just as devastating. A total of 38 people died as a result of this storm, many of them from an overturned boat on the Ohio River. (From the Collection of the Public Library of Cincinnati and Hamilton County.)

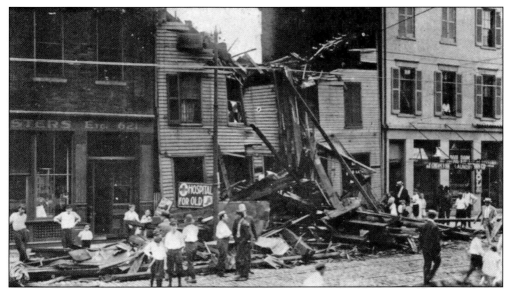

The deadly burst of wind came at the worst time. As it was around 9:00 p.m., people were either in bed or preparing for bed. Among the damage inflicted was the steeple of St. Philomena's Catholic Church being blown completely off, crashing into the old frame houses on Pearl Street. (From the Collection of the Public Library of Cincinnati and Hamilton County.)

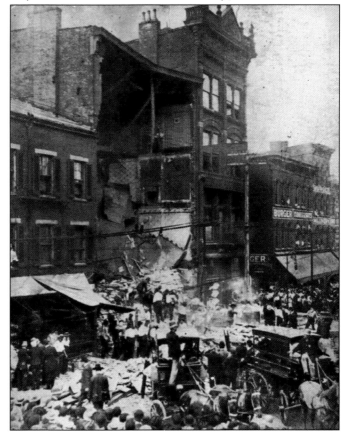

On September 14, 1907, Dohan's Shoe Store at 625 Central Avenue was being renovated. The outside walls suddenly buckled, knocking the main support beam out of place. Suddenly the entire building collapsed. Three deaths were caused by the unfortunate accident, two people inside of the building, and a third who was hit by debris outside. (From the Collection of the Public Library of Cincinnati and Hamilton County.)

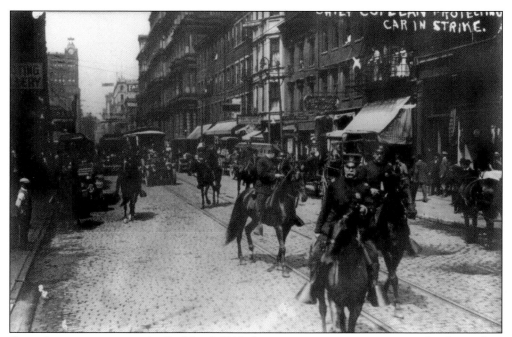

Some disasters are man-made. On May 9, 1913, the streetcar operators went on strike, demanding a raise in pay and recognition of their union. The company responded by hiring scab workers, leading to numerous attacks on streetcars. Here, Chief of Police Copelan and mounted officers personally escort a streetcar. The strike ended on May 19 with recognition of the union. (Library of Congress LC-USZ62-36451.)

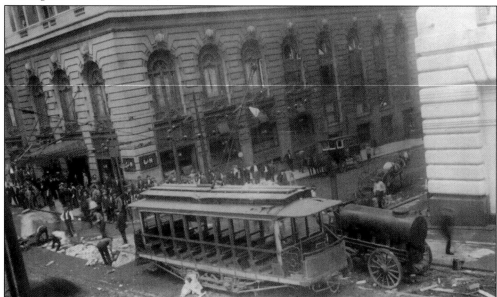

During the strike, numerous streetcars were attacked, and some of them burned—one right on Fountain Square. The most violent encounter resembled a shootout in the Old West. On May 17, a streetcar on Fourth Street was ambushed by strikers hiding in the scaffolding of the Union Central Tower, which was then under construction. Strikers and police fired at each other, while strikers tossed cement down on the streetcar. (Library of Congress, LC-USZ62-76633.)

Nine

HISTORY STARTS NOW

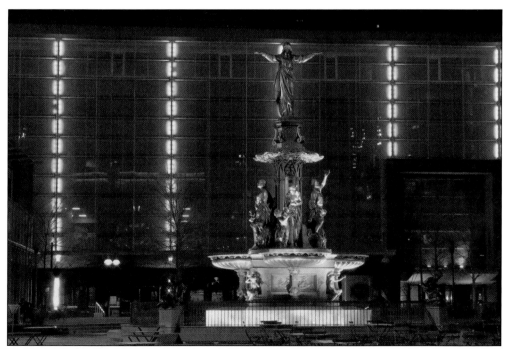

Fountain Square has experienced many changes over the years it has stood as the symbol of Cincinnati. *The Genius of Water* now sits in a large plaza that holds concerts and other events. The fountain is especially radiant at night, as shown here. The bright lines behind the fountain are florescent lights that change color and pattern. (Photograph by Doug Weise.)

Fountain Square was renovated on its centennial anniversary in 1971, then again in 2005. A sign over the Square declares, "Life Happens Here." In the summer, the Square features musical concerts in the evening. Taking an example from New York, in the winter season the Square is the place for ice-skating. (Photograph by Jordan Rolfes.)

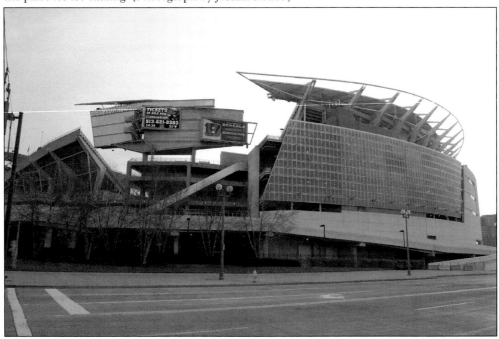

Welcome to the Jungle! In 2000, the Cincinnati Bengals left the old Riverfront Stadium and moved a few blocks west to the new Paul Brown Stadium. With construction funded by a half-percent sales tax, the new stadium is actually designed to look like a football. The stadium seats more than 65,000 fans. (Photograph by Jordan Rolfes.)

Located at almost the exact spot where the first settlers landed in Cincinnati, Great American Ball Park pays tribute to the past. At the end of the stadium are two steamboat smokestacks, from which smoke belches and fireworks explode when the Reds hit a home run or win a game. Around these stacks are 14 baseball bats, a clandestine way of honoring Pete Rose. (Photograph by Jordan Rolfes.)

After half a century of being cut off from its birthplace by an expressway, downtown Cincinnati is finally returning to the Ohio River. Shown here is the construction for the ongoing Banks Project, an attempt to revitalize the front door of downtown Cincinnati. Already open is the National Underground Railroad Freedom Center, a museum honoring those who risked their lives for the sake of freedom. (Photograph by Jordan Rolfes.)

Wilkommen to Zinzinnati! Each year the city of German immigrants proudly hosts the world's second largest Oktoberfest, second only to its sister city Munich in Bavaria. Stretching on Fifth Street from Vine Street across town to Broadway, half a million people flock to downtown to celebrate the city's German heritage. (Courtesy of CincinnatiUSA.)

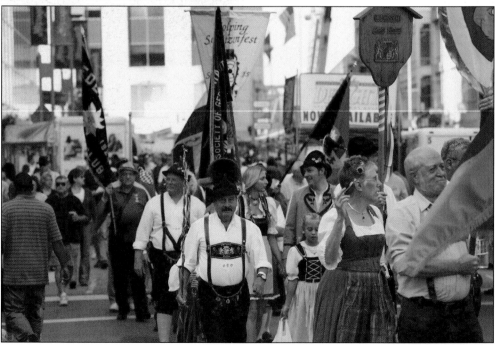

While the city may be forced to bow to Munich for the honor of having the largest celebration, Cincinnati does have one record that it holds dear. To open the festival, Fountain Square becomes the site of the world's largest Chicken Dance. Chickens become a fashion statement as street vendors sell hats with the birds on them. (Courtesy of CincinnatiUSA.)

This marvelous relief, located at the Fifth Street entrance to the Omni (now Hilton) Hotel, is reportedly a depiction of the Hindu god Shiva. It is remarkable not only from an artistic standpoint—an Art Deco Hindu god, gold on a black background—but it also speaks volumes about the character of downtown Cincinnati. Placed over the door of a fashionable hotel, where people come and go, it symbolizes the downtown area, which both comes and goes. According to Hindu belief, Shiva is the god of destruction but also the deity of rebirth. And, like Shiva, downtown Cincinnati is perhaps being slowly destroyed under the weight of the wrecking ball, only to be replaced by larger and more magnificent structures—a process that shall certainly continue as long as there is a downtown Cincinnati. (Photograph by Doug Weise.)

DISCOVER THOUSANDS OF LOCAL HISTORY BOOKS FEATURING MILLIONS OF VINTAGE IMAGES

Arcadia Publishing, the leading local history publisher in the United States, is committed to making history accessible and meaningful through publishing books that celebrate and preserve the heritage of America's people and places.

Find more books like this at
www.arcadiapublishing.com

Search for your hometown history, your old stomping grounds, and even your favorite sports team.

Consistent with our mission to preserve history on a local level, this book was printed in South Carolina on American-made paper and manufactured entirely in the United States. Products carrying the accredited Forest Stewardship Council (FSC) label are printed on 100 percent FSC-certified paper.

MADE IN THE USA